The College History Series

COLUMBIA
COLLEGE

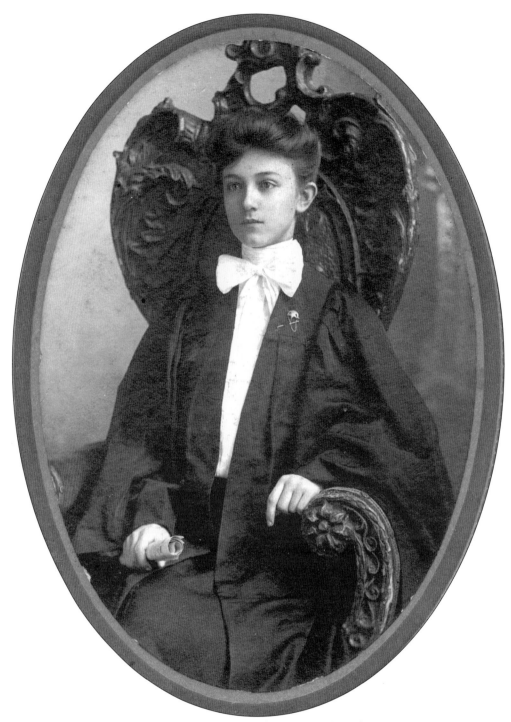

Mattie Tarrant, pictured here, was a member of the Class of 1904.

The College History Series

COLUMBIA COLLEGE

CHARLES ISRAEL AND ELIZABETH DURANT

ARCADIA

Published by Arcadia Publishing,
an imprint of Tempus Publishing, Inc.
2 Cumberland Street
Charleston, SC 29401

Printed in Great Britain.

Library of Congress Catalog Card Number: 2001087922

For all general information contact Arcadia Publishing at:
Telephone 843-853-2070
Fax 843-853-0044
E-Mail sales@arcadiapublishing.com

For customer service and orders:
Toll-Free 1-888-313-2665

Visit us on the internet at http://www.arcadiapublishing.com

This book is dedicated to all the loyal Columbia College alumnae
who have created and nourished the spirit of the college,

and to

the memory of
Jerold J. Savory (1933–1998)
teacher, scholar, friend.

On the Cover. This photograph was given to the archives in 1980 by the family of Annie
Stackley (Class of 1910). The picture appears in the 1910 *Columbian* entitled "Senior
Champions." They are Captain Mary Belle Manning, Annie Stackley, Kate Murchison, Grace
Terrell, Lucile Byrd, Ella Rowe Dukes, Ruth Williams, Mayme Green, Rebecca Nichols, and
Bettie Gibson.

CONTENTS

ACKNOWLEDGMENTS

The authors would like to thank those whose assistance has made this book possible. In particular, we owe a large debt to Meg McLean, the college's publications designer, who, in truth, is a co-author of this work. Her expertise and advice were indispensable. We also want to thank Dale Bickley, Janet Alexander Cotter, Amy Fordham, Sally Jenkins Harm, Edith Hause, Emil Mitchell, June Mullinax, Sara Nalley, Chuck Pfeiffer, Amanda Potts, Jim Poindexter, John Pritchett, and Miriam Rawl for their help and advice.

We also want to acknowledge our debt to Jerold J. Savory's history *Columbia College: The Ariail Years*; to Dr. J.M. Ariail's short history of the college, first published in the *Methodist Advocate*; and to Evelyn Barksdale Winn's 1927 M.A. thesis, *A History of Columbia College*.

INTRODUCTION

The Methodist Conference of South Carolina funded Columbia Female College in 1854 as a part of a national surge in the establishment of church-related liberal arts colleges. As we approach the college's sesquicentennial celebration, it is fitting to take a retrospective look at the people and events which have shaped and sustained the institution through the decades.

The long history of Columbia College has been built by the endeavors of tens of thousands of people, past and present, who have held forth the ideal of a liberal arts college for women as a mainstay of our culture. That ideal has survived and flourished for almost a century and a half, through periods of prosperity and growth as well as through periods of struggle and cataclysmic destruction.

A look into the recorded history of the college will point to the palpable spirit that has sustained the college through severe trials. One such test came when the college was forced to close its doors in 1865 because of the physical and economic devastation caused by the Civil War. For eight years afterwards, Methodist ministers, lay people, and supporters of the college canvassed the state's churches and communities asking for money to reopen the college. The annual reports of the Methodist Conference attest to their diligence and commitment on behalf of the college. South Carolina's destitute citizens contributed their scarce pennies and nickels to the cause. Hard work and sacrifice allowed the college to reopen in 1873 with renewed hope and energy.

In the last century, the college survived two devastating fires. In 1909, the elaborate structure built on the site of the present campus was completely destroyed by fire. And, in 1964, Old Main and East Wing burned. After each fire, the college community turned its energies and resources to rebuilding.

This book pays homage to all those who have embodied the Columbia College spirit in their lives.

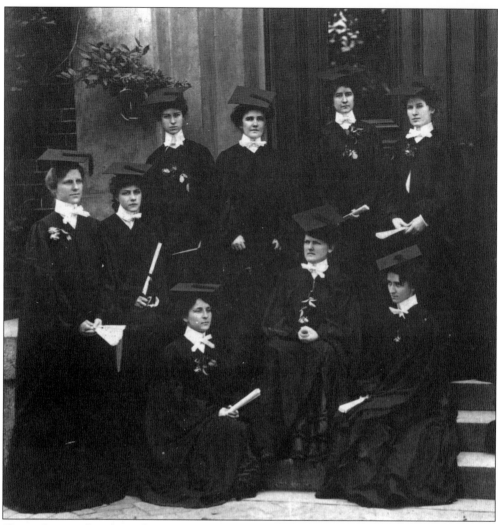

Shown here is the Class of 1902. Though only 9 are pictured, 16 graduates are listed in the 1902 Columbia Female College bulletin; they are as follows: Mary Eliza McLeod, Alice Blanche DesChamps, Belle Simrill, Mable Pearle Johnson, Fannie Sue Koger, Minnie Wright Bollin, Mary Lilly Warner, Etta Blanche Skinner, Eva Nancy Stuckey, Frances Almira Davis, Ellinor Miller, Maria Michaux, Ethel Gwendolyn Rice, Jessie Goodwyn Patterson, Augusta Sprott, and Ethel Gwendolyn Rice.

One
THE EARLY DAYS

The smallest graduating class in the history of the college was in 1896, and it consisted of, from left to right, Hettie Pooser, Camilla King, and Mary Alice Dent. There was a total enrollment that year of 135 students.

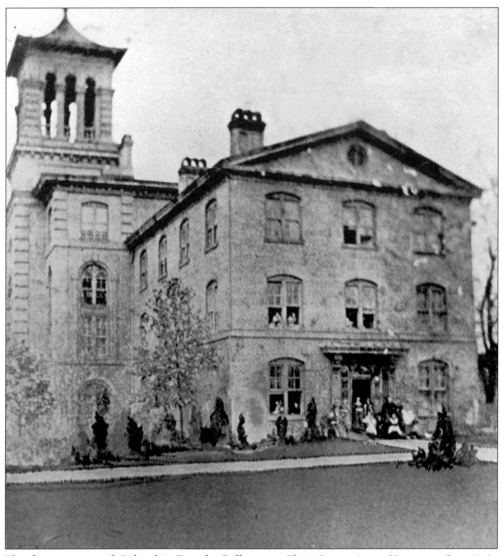

The first campus of Columbia Female College on Plain Street (now Hampton Street) in downtown Columbia is pictured here in 1896.

Columbia College's first president was Reverend Whitefoord Smith, who served in that position from 1859 until 1860.

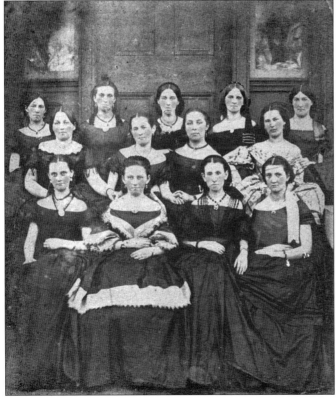

The first graduating class is pictured here in 1860. According to Dr. J.M. Ariail's historical sketch, "the coming of Sherman's army in 1865 caused the exit of the student body." The college was closed from 1865 to 1872, as the state suffered the economic hardships of Reconstruction. Dr. Ariail concludes this section of his history with the following sentence: "Finally, the college reopened, having shared with the city of Columbia in the travail and agony of the war, and like the city undefeated and by no means devoid of life."

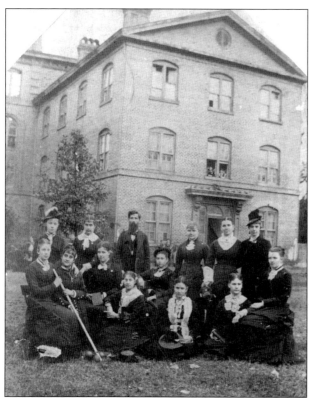

The Class of 1874 poses with the college's fourth president, Samuel B. Jones, who served two terms, 1873–1876 and 1890–1894.

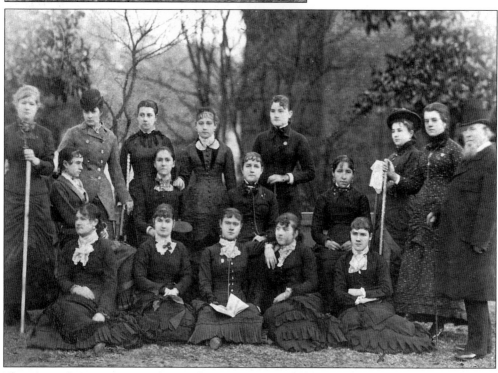

The Class of 1879 is seen with President J.L. Jones (1876–1881).

In 1904, benefactor Frederick Hargrave
Hyatt gave the land on which the
college and College Place Methodist
Church are now located. The move of
the downtown Columbia campus to its
present site took place in 1905.

Here, the Hyatt children are seen
breaking ground for the new building
on December 1, 1904.

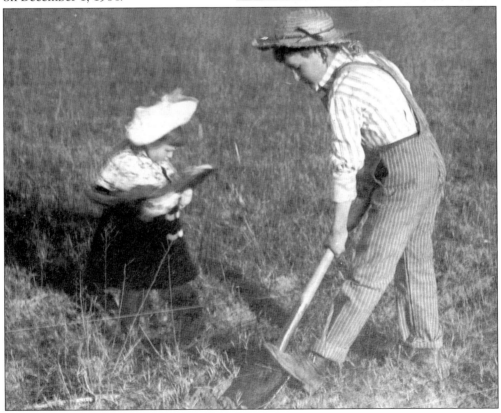

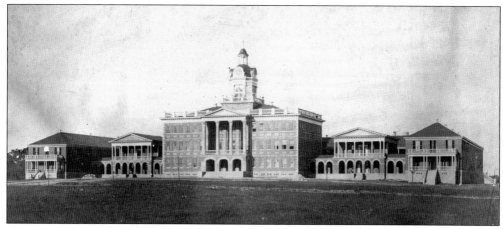

The new campus is pictured here in 1905. In 1904, benefactors F.H. Hyatt and Colonel John T. Sloan donated land for the new campus, then outside the city of Columbia. The new plant contained classrooms, offices for administration and faculty, modern dormitories, a gymnasium, and a swimming pool. When the campus was moved to its present site, the word "Female" was dropped from the college's name. One of the "special advantages" advertised in the college's 1909–1910 catalog was "our suburban location gives quietude for study and freedom of country life."

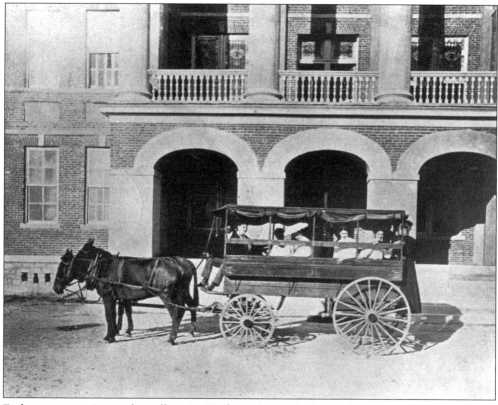

Early transportation to the college in 1906 consisted of a horse-drawn wagon.

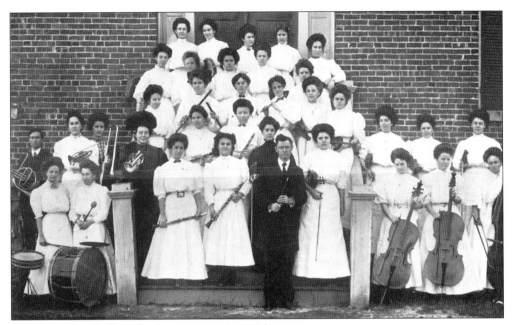

The Columbia College Orchestra poses in 1904.

The faculty in 1918 poses for this portrait on the steps of Old Main. Dr. J.M. Ariail and Dean David D. Peele appear at the far left; President G.T. Pugh stands at far right.

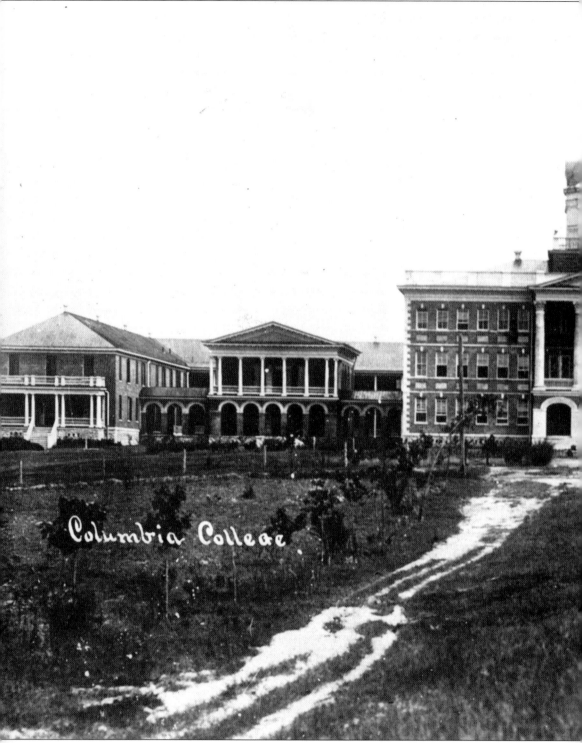

Columbia College

This grand structure, complete with dormitory wings, comprised the college on its new suburban site for four years. It was built in 1905 and was destroyed by fire in 1909.

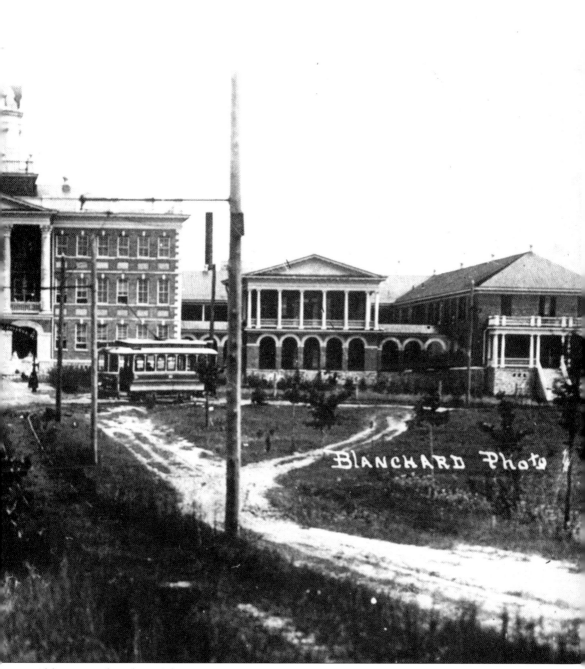

Old Main replaced it on this site in 1910.

President W.W. Daniel stands with the Ariail and Cleveland houses in the background, 1900.

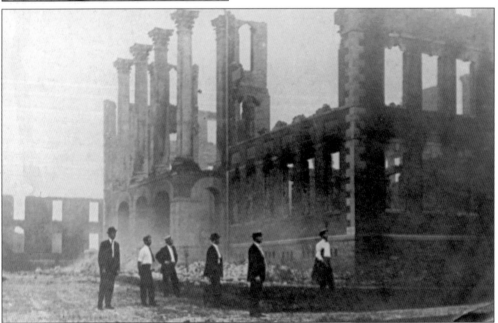

On September 9, 1909, the new building was destroyed by fire. The remains of the campus afterward are shown here. President W.W. Daniel was injured while saving the records of the college from the burning building. After the catastrophe, Daniel rented the former downtown building of the Columbia Female College, and the college reopened several days after the fire. In one year, the college was rebuilt on its old foundation at the present site.

Dr. John Andrew Rice, the college's sixth president, served from 1894 to 1900. In her history of the college, Helen Jordan writes that President Rice "was instrumental in elevating the curriculum to an equal level with that of male colleges. For the first time, the Bachelor of Arts and the Bachelor of English degrees were given." In 1898, the Bachelor of Science degree was offered.

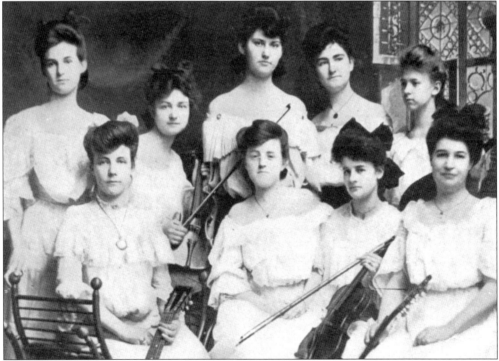

Music students are shown here in 1894. The college's first faculty in 1860 totaled 12 members, and of these, 5 were instructors in music.

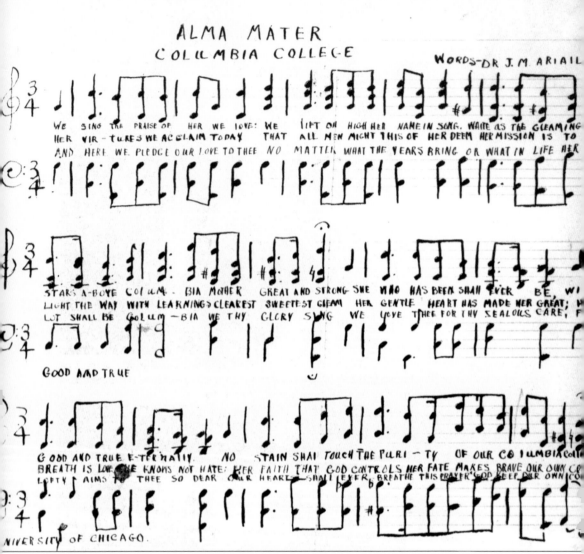

ALMA MATER
COLUMBIA COLLEGE
WORDS-DR. J. M. ARIAIL

Dr. Ariail's original manuscript of the Alma Mater was first published in 1917, when he was in his fifth year of teaching. "Originally," he later wrote, "I wrote four stanzas." The third, the "fire stanza, refers to the disastrous fire that destroyed Columbia College in 1909 and attempts to express the feeling that Columbia College cannot be destroyed by disaster. She's accustomed to surviving all kinds." Here is his fire stanza:

The storms of years upon her beat, but do not scar her loving face,
And fire has wrapped her in its heat, but on her soul has left no trace.
The travails of her mother heart, as from her side her daughters part—
We know then thy quick tears start, Oh, gentle Alma Mater!

20

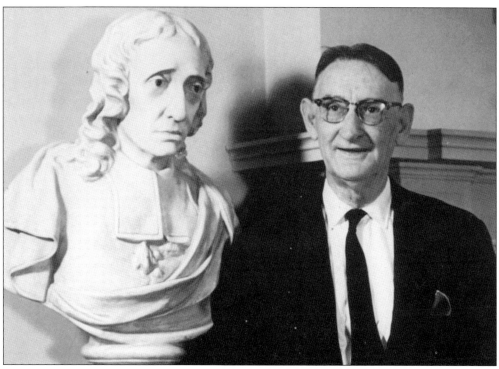

Dr. J.M. Ariail is shown here in the English department with the bust of John Milton, one of his favorite poets. Dr. Ariail joined the faculty in 1912 and served as professor of English and chairman of the English department until his retirement in 1968.

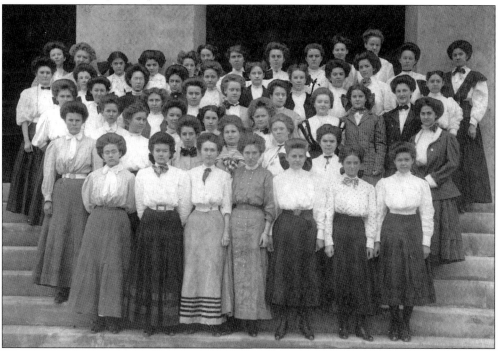

Shown here is the Class of 1912.

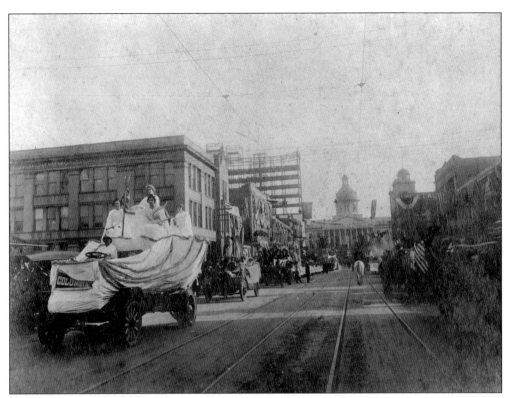

Columbia College participated in the Corn Exposition Parade on Columbia's Main Street, January 28, 1913. The frame of the Palmetto Building, South Carolina's first skyscraper, is seen in the background. On the float, college students pose as the Muses, those spirits from Greek mythology thought to inspire poets and other artists.

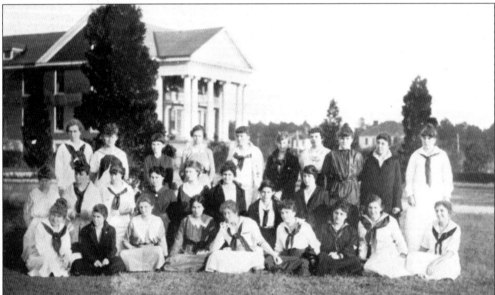

The East Wing of Old Main is seen in the background of this photograph showing students in 1918.

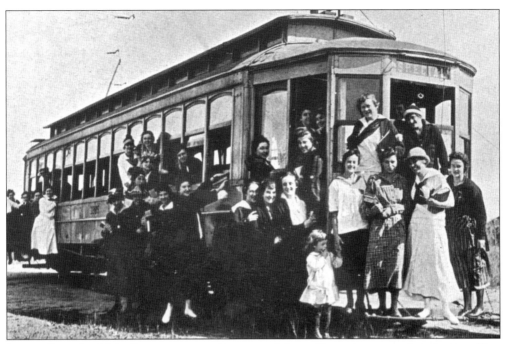

A spur from the Main Street streetcar line served the college. A group of students calling themselves "the Kar Katchers Union" is pictured here in 1917.

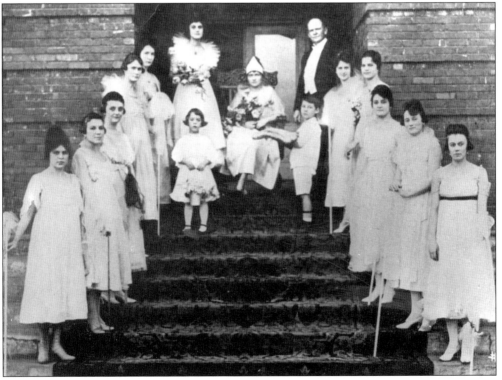

The May Day celebration started in 1909 and continued until 1995. The 1918 May Queen and her entourage are pictured here. President Pugh is seen at top right.

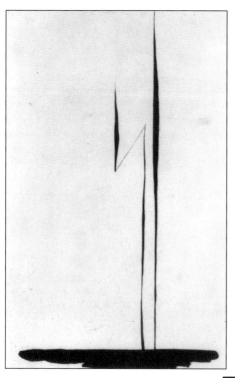

Georgia O'Keeffe's *Blue Lines* was painted in 1916 while she was teaching at Columbia College.

The famous American artist Georgia O'Keeffe taught art at the college in 1915–1916. This photograph was taken by her husband, Alfred Stieglitz. In 1979, O'Keeffe reminisced about her work at Columbia College: "I had a room next to the Ariails. I also had a room to work in for myself. In that room I had an exhibition of the work I had done with various teachers and when I looked at it and thought about it—I realized with each picture I was trying to work as each teacher had taught me and wanted me to. Thinking of that—it occurred to me I had ideas of my own I had never put down before as I had never seen things like them. It was an important time in my life and some of my most important early drawings were made at that time at Columbia College. It started me on my way."

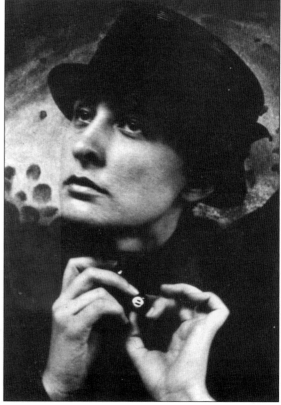

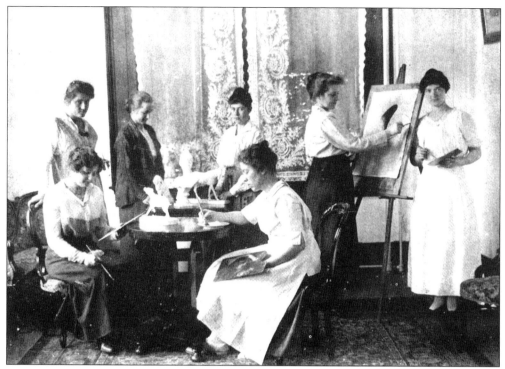

Most members of the Art Club in 1916 were O'Keeffe's students.

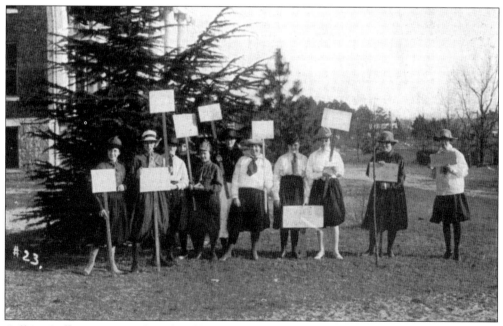

College Suffragettes pose beside Old Main in 1914.

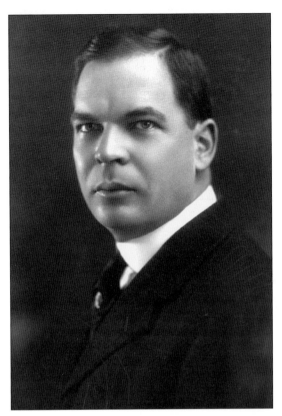

Dr. John Caldwell Guilds was president of the college from 1920 to 1948, the longest presidential tenure in the college's history. Upon assuming office, Guilds set the following goals that were realized over the years: (1) to complete the unfinished sections of the administration building; (2) to increase the endowment; (3) to increase student scholarships; (4) to qualify for membership in the Southern Association of Colleges and Secondary Schools; and (5) to advance the college to become an academic leader in the state's higher education.

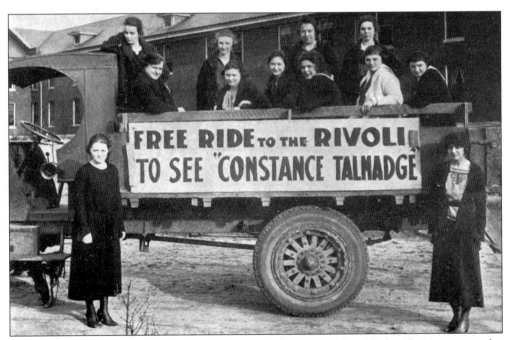

Students accept a free ride to the Rivoli Theater in 1920. Constance Talmadge was a popular silent movie star.

Junior Debaters in 1915, from left to right, were Louise Carter and Grace Killingsworth of the Wightman Society; Eunice Clarkson and Eula Winn of the Carlisle Society.

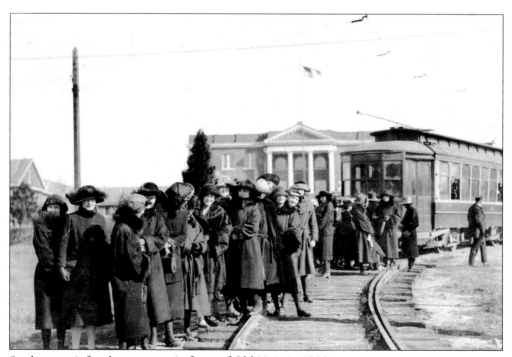

Students wait for the streetcar in front of Old Main in 1920.

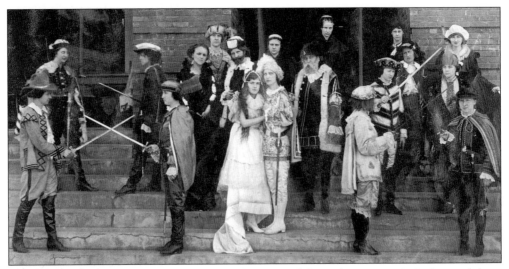

In the early twentieth century, commencement was celebrated over a period of several days, highlighted by the production of plays on campus. In 1920, the commencement play was *Romeo and Juliet*.

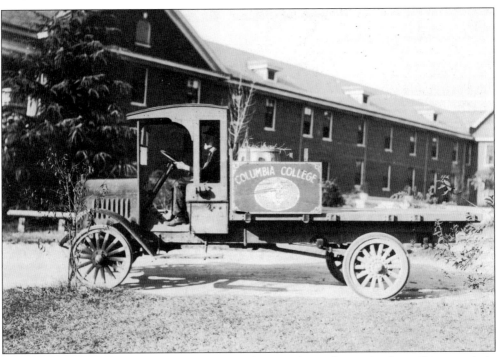

Mr. Kerr, superintendent of maintenance and grounds, is shown in the college truck in 1923. The son of President Griffith T. Pugh once remarked that in those days the college security force was comprised of "Mr. Kerr with a wrench in his back pocket."

Anne Frierson Griffin, seen here as a cheerleader in 1924, later joined the faculty to teach creative writing and speech and became chair of the speech department. She wrote the script for the *Columbia College Centennial*, a historical pageant celebrating the college's 100th anniversary in 1954.

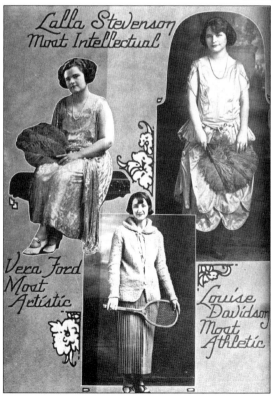

Other students from the 1920s are shown here.

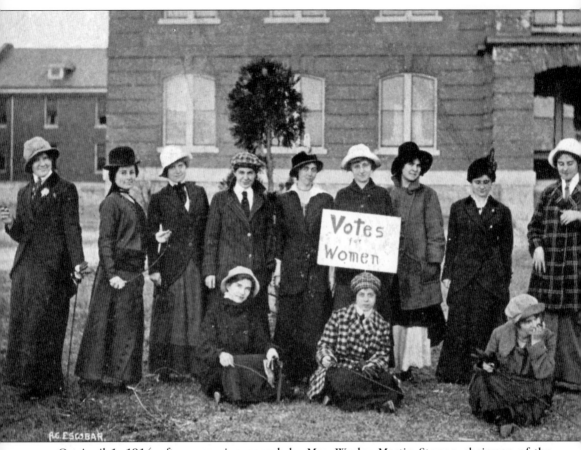

On April 1, 1914, after a rousing speech by Mrs. Wesley Martin Stoner, chairman of the Southern States Suffrage Associations, about half the student body cut classes to stage a suffrage rally in downtown Columbia. "Suffragists" from Columbia College are shown here in 1918.

Two
STUDENT LIFE

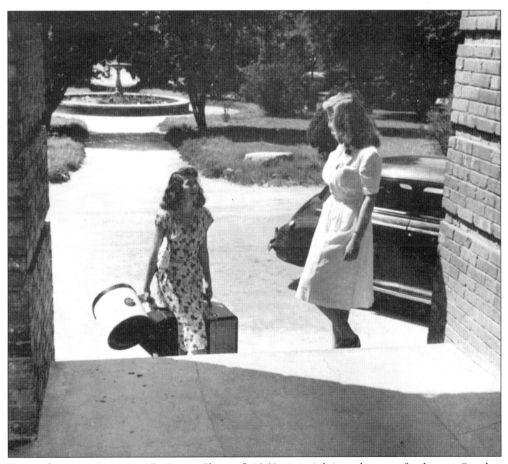

Upperclassman Margaret DuRant, Class of 1948, (at right) welcomes freshman Carolyn "Sissie" Snow, Class of 1951.

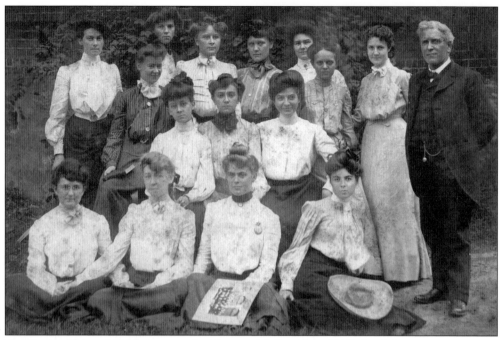

The Senior Class of 1904 poses as the Muses with President W.W. Daniel.

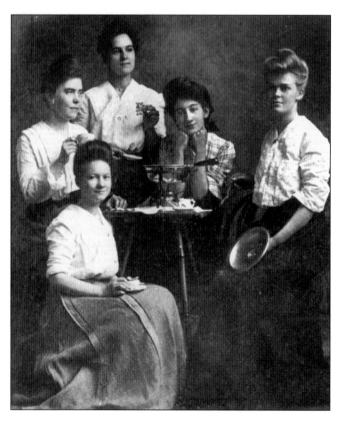

Members of the Chafing Dish Club of 1908 are portrayed in this image.

The Criterion is one of the oldest continuously published student literary magazines in the nation, having been established in 1897. In addition to literary work, the magazine contained college and alumnae news, jokes, and advertisements. *The Criterion* celebrated its golden anniversary in 1997 with a retrospective issue, reprinting some of the most memorable poems, stories, and essays from past issues.

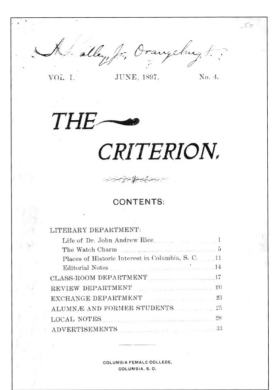

VOL. I. JUNE, 1897. No. 4.

THE

CRITERION.

CONTENTS:

COLUMBIA FEMALE COLLEGE,
COLUMBIA, S. C.

The Criterion staff of 1905 poses in this photograph.

Members of the Martha Washington Club in 1907 are joined by male friends, one of whom is the son of President Daniel.

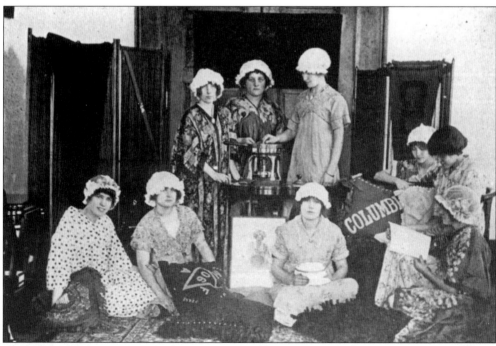

Student friends teamed together to form homegrown clubs. The Fudge Club of 1914 is shown here. These clubs were substitutes for national sororities.

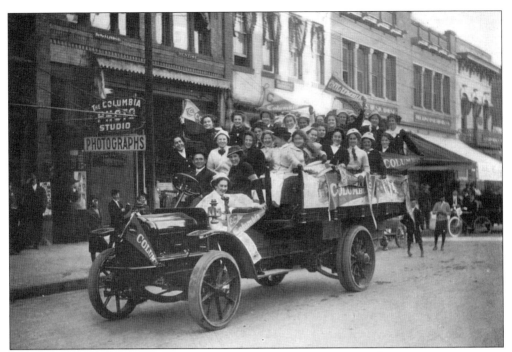

The Columbia College Joy Riders of 1911 ride in a Main Street parade.

The Runaways, whose motto was "Never stay when you can slip away," are shown in 1916.

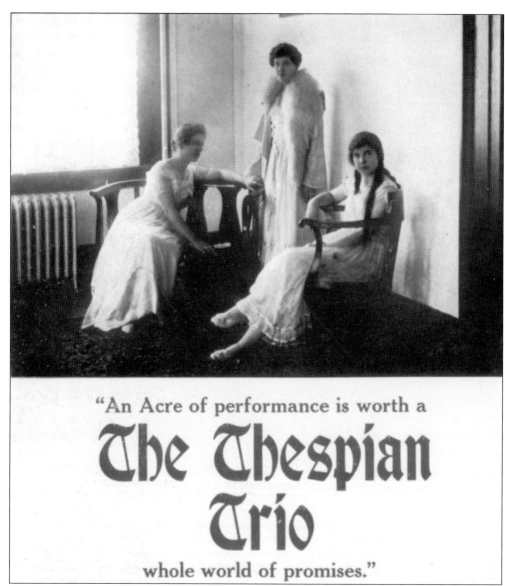

"An Acre of performance is worth a

The Thespian Trio

whole world of promises."

The Thespian Trio in 1916, from left to right, are Addie Rembert, Wilhelmina Ariail, and Marie Salley. Their motto was "An acre of performance is worth a whole world of promises."

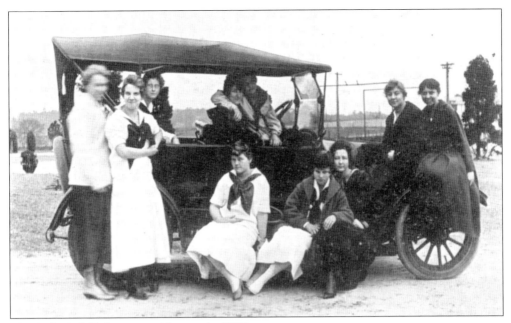

The Only Girl Club poses with a car in 1917.

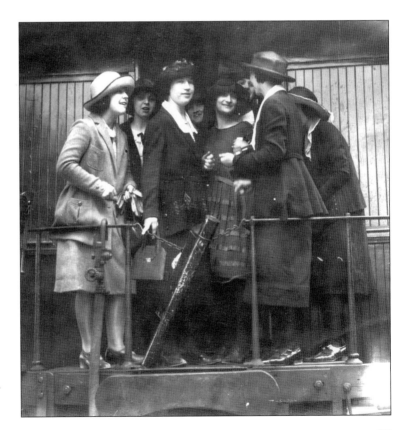

Columbia College students board the train for home from the Columbia railroad station, *c.* 1920.

Sadie Harter Cooner, a member of the Class of 1919, celebrated her 100th birthday in 1998 by playing ragtime on the piano, a skill she practiced as a music student at the college.

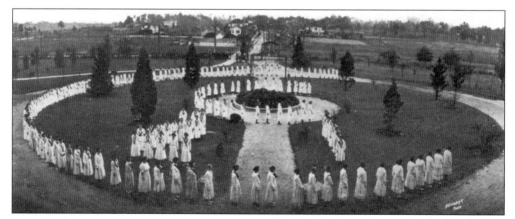

Students form a daisy chain in the shape of a double C and the year 21 in front of Old Main. The present Columbia College Drive did not exist in 1921.

38

Florence Howell was the business manager of the *Columbian* yearbook in 1925.

Mary Holler Rice, Class of 1929, was a missionary to China and a professor of English at Clemson University. In 1999, she received the Alumnae Association's Outstanding Educator Award.

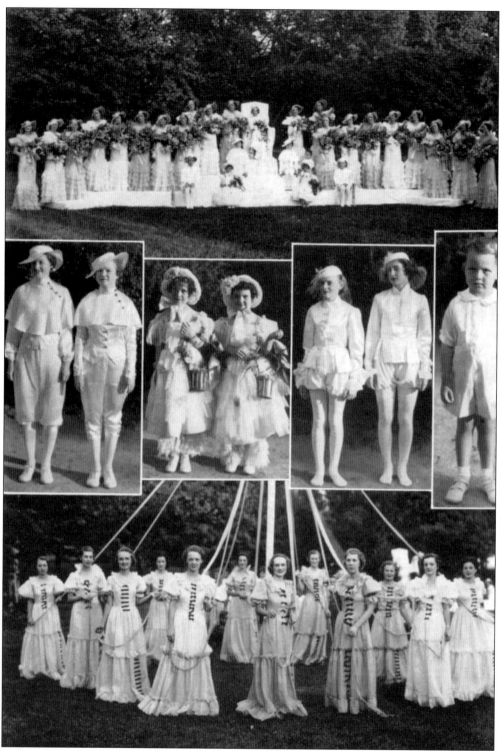

Evelyn Plowden was May Queen in 1935 when May Day was a much-anticipated and well-celebrated annual event. She is seen here seated in the center of the top photograph.

40

Ellen Guess poses here in a tableau illustrating her favorite song, "Mighty Lak a Rose." She was voted "daintiest" by her fellow students in 1929.

Josephine Peele, daughter of Dean David D. Peele and shown here in 1934, was voted "friendliest" by her senior classmates.

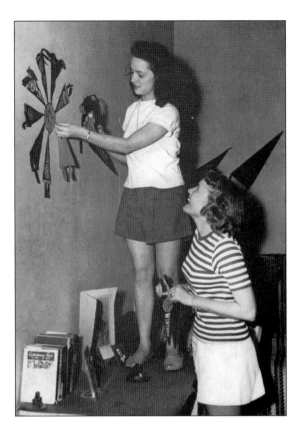

Students Louise Barber (at left) and JuAnne Kennedy, Class of 1948, hang pennants in the dormitory, 1946.

Pi Phi's (day students) are pictured here in 1940.

The *Post Script*, the student newspaper, was first published in mimeograph form in September 1945. Pictured here is Lorraine Burke, editor from 1949 to 1951. Her daughter, Mollie Marchione, is a 1980 graduate.

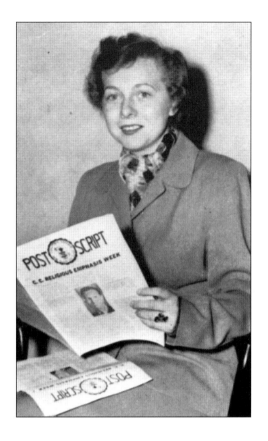

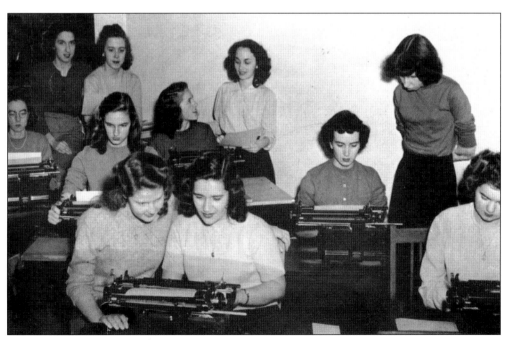

The *Post Script* staff in 1949 works to meet a deadline.

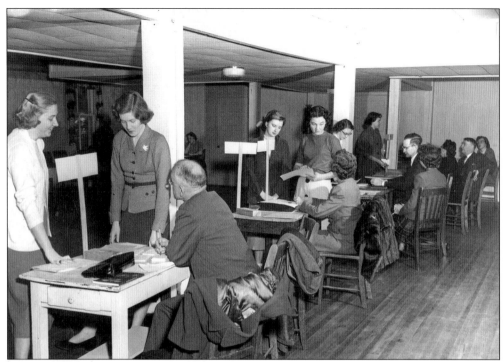

Students are seen here registering for classes, 1952–1953.

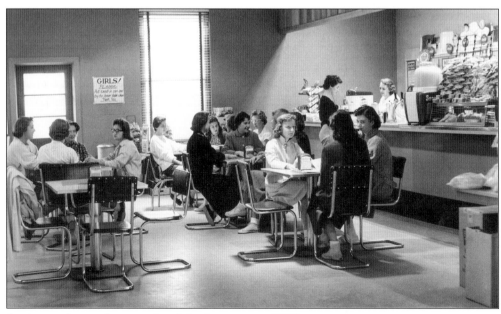

Students take an afternoon break in the canteen, 1958.

Betty Lane Cherry was May Queen in 1958. Later, she was crowned Miss U.S.A.

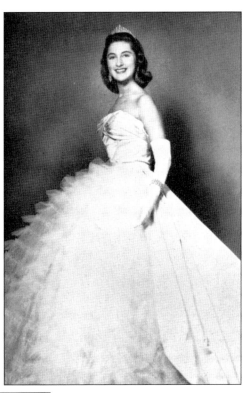

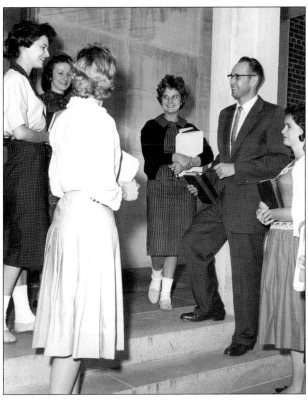

Professor Charles Pfeiffer talks with students in 1959. Mr. Pfeiffer was a professor and the chair of the religion department for almost 36 years.

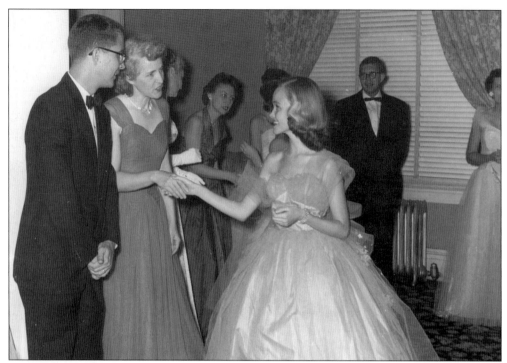

A cherished tradition was the introduction of new students to faculty and staff during the freshman reception, for which formal attire was required. Music professor Guthrie Darr is seen at left.

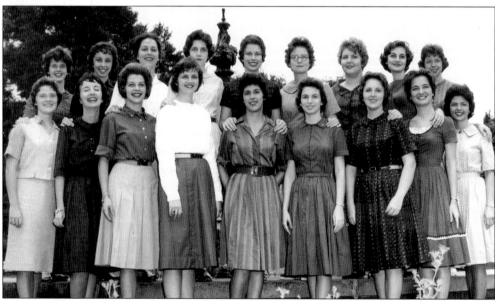

Shown here are 18 sisters who attended Columbia College in the 1950s. They are from left to right (bottom to top) as follows: Rebecca and Beth Taggart, Libby and Carole Judy, Sissi and Beverly Williamson, Betty and Carolyn Hudgens, Frankie and Ernestine Powell, Jeane and Nancy Culler, Rolan and Marilyn Cleveland, Maggie and Brenda Jones, and Betty Jean and Emily Shuler.

Tootsie Dennis was Columbia College's 1962 May Queen. She had been crowned Miss South Carolina in 1960 and later authored a book, *Miss South Carolina Pageant*, on the 25th anniversary of the pageant in Greenville.

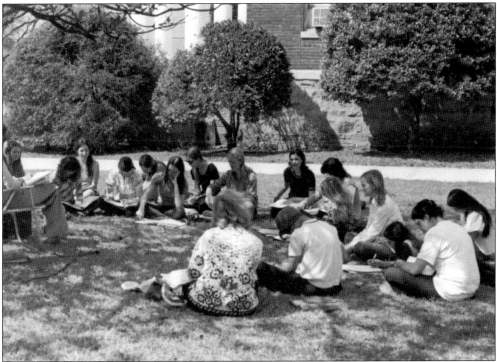

Students enjoy the warmth of a spring afternoon during a class beside East Wing in the early 1960s.

Karen Cribb was chosen "most womanly" in 1964. For decades, the "most womanly" award was one of the most coveted student honors. In the late 1990s, this award was renamed the Savory Award to memorialize contributions of faculty member and administrator Jerold J. Savory.

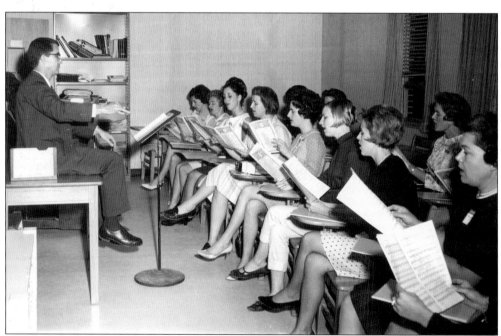

Professor Guthrie Darr directs the Alumnae Chorus on Alumnae Day, 1967. Darr spent 44 years on the faculty of the music department from 1949 to 1993.

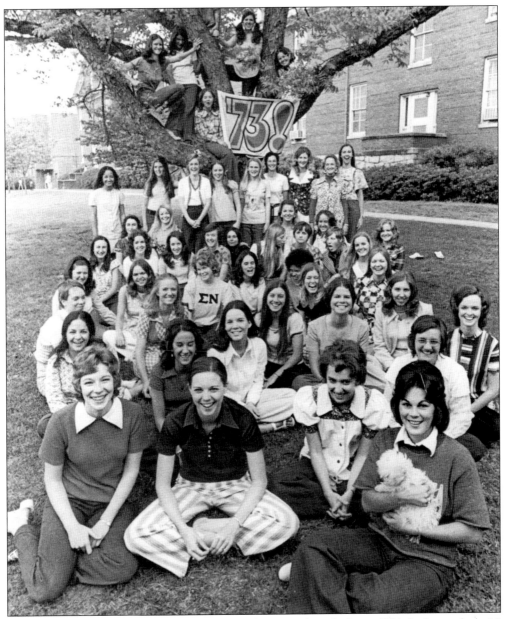

This picture of the Senior Class of 1973 has the period catchphrase "If it feels good, do it" below the photograph in the *Columbian* yearbook.

A freshman student is dressed for Rat Week in 1975. For decades, Rat Week was a fixture of orientation for freshmen, including pranks, jokes, and mild hazing.

Sophomore class officers in 1972, from left to right, included Maj Finklea, Ann Pridgen, Beth Odom, and Liz Mellette.

The Galilean Service at Pine Island, Lake Murray, in the 1980s marked the beginning of the college experience for incoming freshmen.

Gonzales Hall students practice for Follies in 1988.

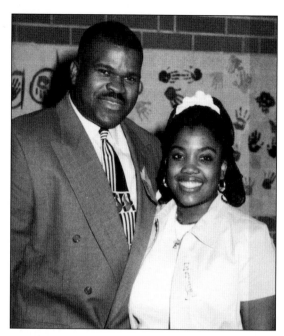

Erica Nelson and her father are shown at Dad's Night in 1999. Dad's Night was instituted in the 1980s to complement Mom's Day.

Columbia College students studying in Angers, France, in 1996 take a moment for a group photo.

Honors student Melody Johnson Harvey, Class of 1995, conducted speech language pathology field work above the Arctic Circle.

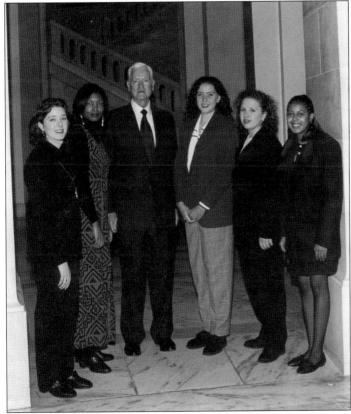

U.S. Senator Ernest F. Hollings, a Democrat from South Carolina, poses with participants in the college's first Washington semester in 1998. They are, from left to right, Ann Kidd, political science professor Dr. Sheila Elliott, Hollings, April Whitney, Jennifer Gill, and Keisha Dicks.

53

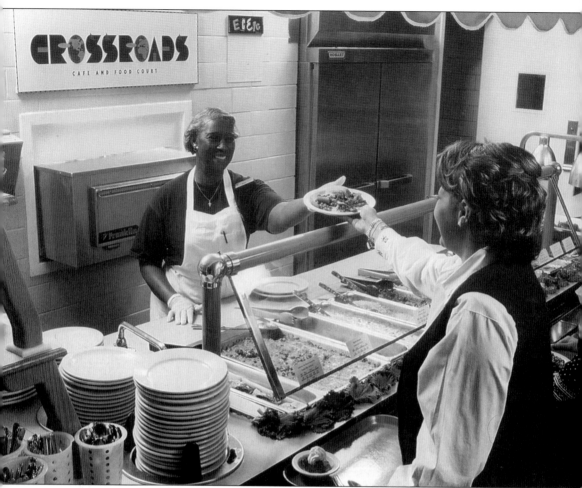

Rosa Rawson serves food in the cafeteria, 2000.

Three

CAMPUS VIEWS

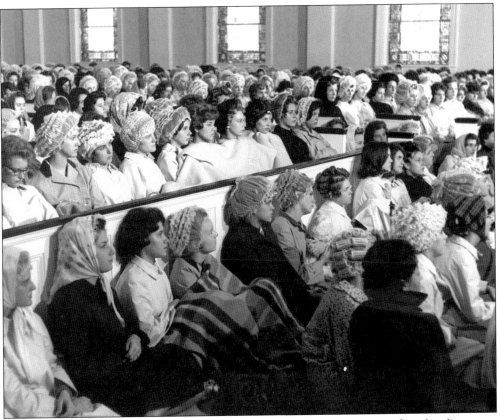

Shocked students assemble in College Place Church on the morning after the disastrous February 12, 1964 fire, which destroyed Old Main and East Dormitory. President Wright Spears told the assemblage, "Nothing has been destroyed that cannot be rebuilt," a sentence spoken in thanks for the fact that no one was injured during the orderly evacuation of the burning building. For years, Miss Ludy had been religiously enforcing frequent fire drills on the resident students, a regimen that was a lifesaver.

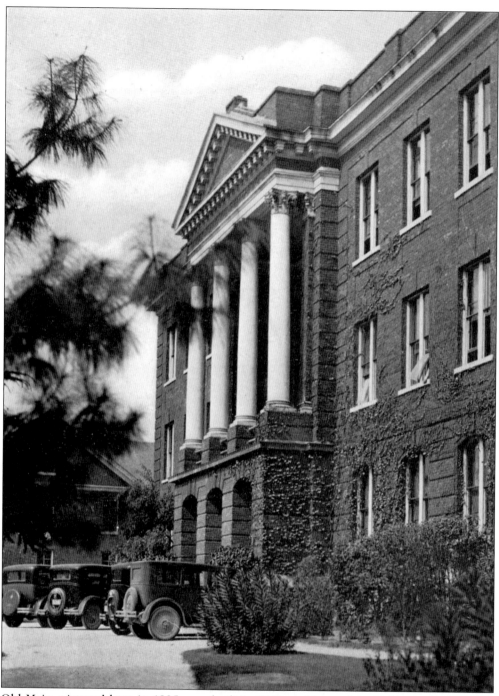

Old Main, pictured here in 1935, was built in 1910 and burned in 1964. For many years, it housed the auditorium, dining room, parlors, classrooms, and administrative offices. Old Main and its East and West Wings were the only campus buildings until the library was built in 1922.

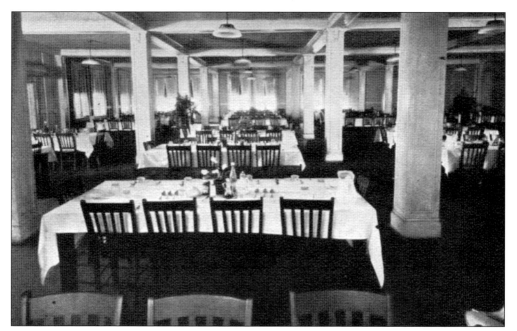

Pictured here is the dining room of Old Main, where a senior served at each table.

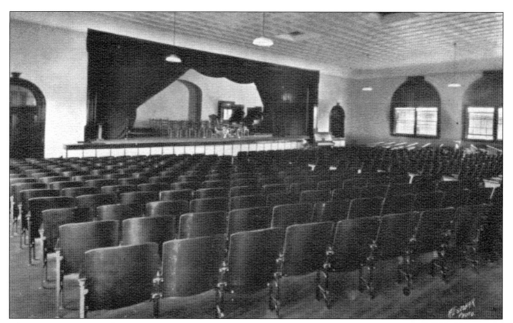

The auditorium of Old Main was the scene of Wednesday chapels, Shakespeare plays, graduation exercises, and many other important events.

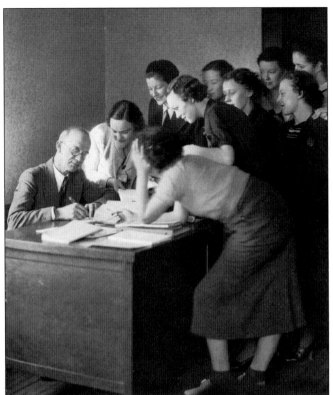

Dean David D. Peele, who served the college from 1910 to 1948, is remembered by many alumnae for his love of mathematics, his abiding sense of fairness, and his intelligent wit. He also served for several years as editor of the *Methodist Advocate*.

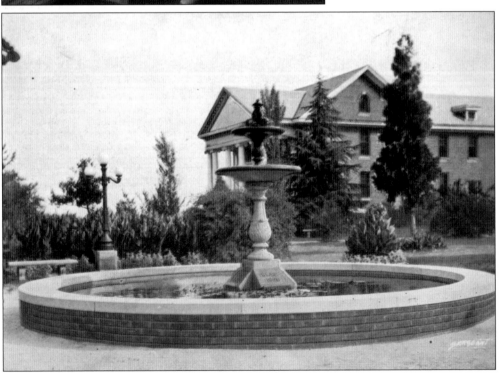

The landmark Fountain of the Classes was the gift of graduation Classes 1925–1928.

College Place United Methodist Church was organized in 1914 and held services at Columbia College for the first eight years of its existence. President W.W. Daniel served as chairman of the committee to direct plans for the new church building. Mrs. Daniel was the first president of the Woman's Missionary Society. The church continues to be used by the college for chapel meetings and other services.

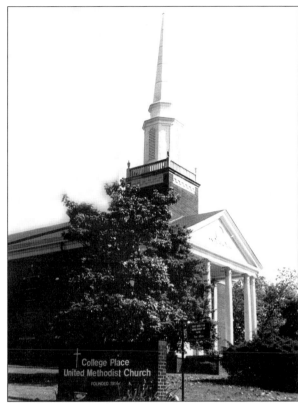

Students leave for church in the 1940s.

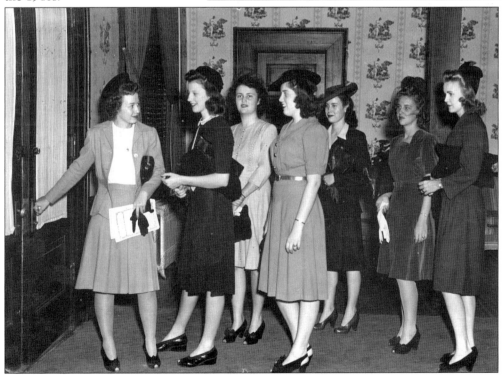

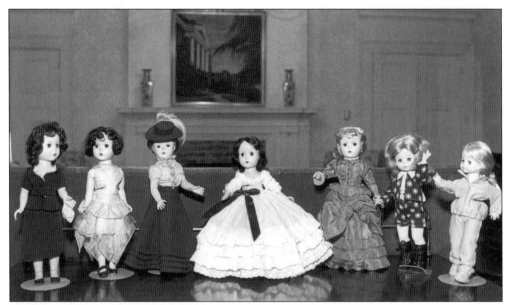

This is a portion of the doll collection gracing Alumnae Hall. In 1953, Dean Thomas G. Shuler suggested that the alumnae dress a doll for each year of the college's existence. After that, each senior class would dress a doll in the current fashions. The dolls fill the cabinets in Alumnae Hall.

Freshmen students and their mothers arrive on campus in 1952.

Sophomore class officers are pictured at the fountain in front of Old Main in 1957. From left to right, they are Marlene Deloach, Sybil Gaddy, Barbara Mackey, Peggy James, and Betty Davis.

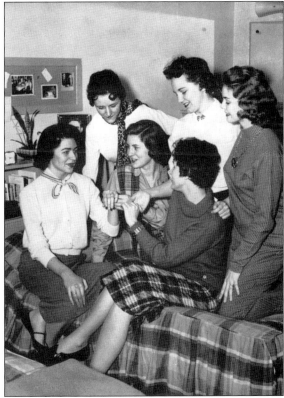

Two happy seniors have returned from Christmas holidays with engagement rings, 1959.

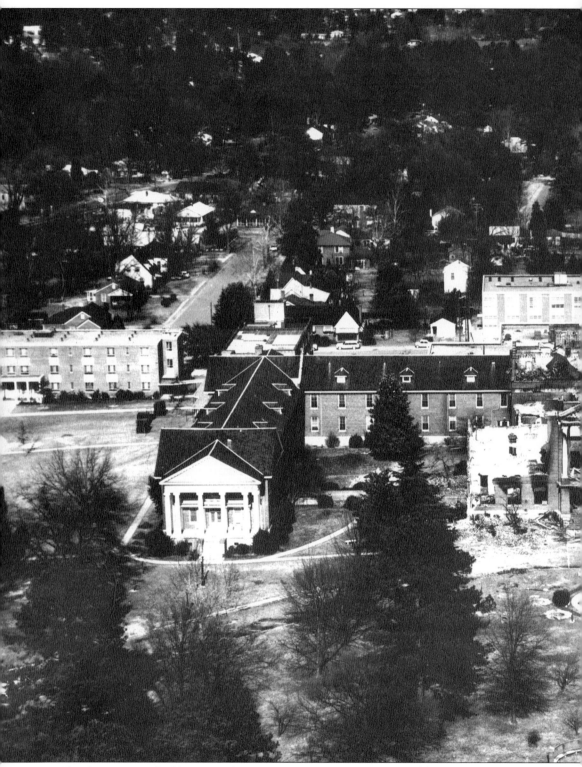

The destruction of Old Main and East Dormitory caused by the 1964 fire can be seen in this

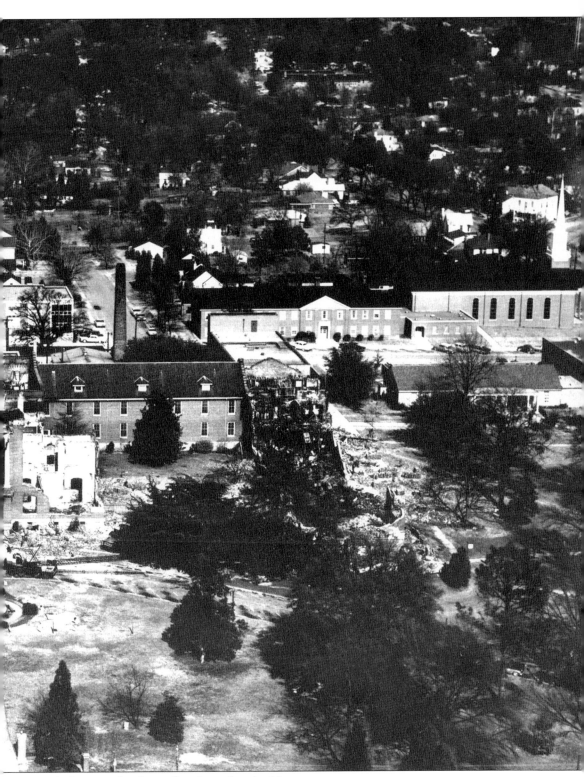

aerial photograph taken a few days after the blaze.

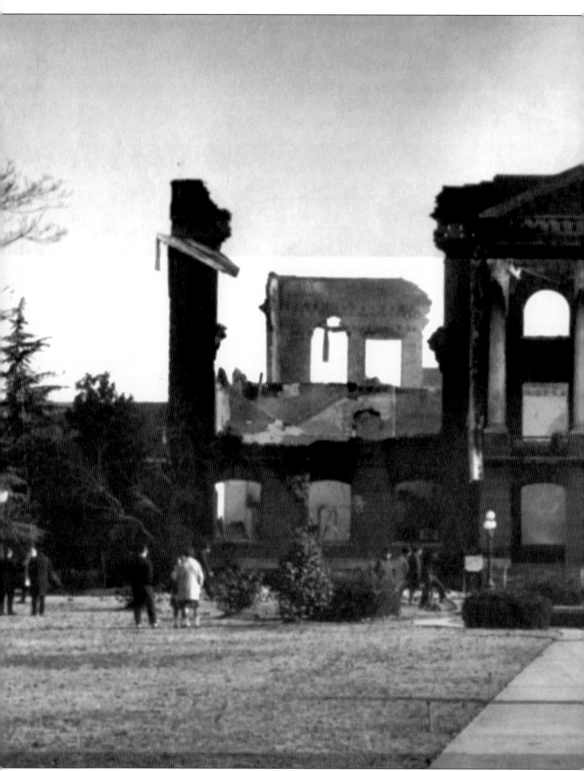

Observers view the ruins on the morning after the 1964 fire.

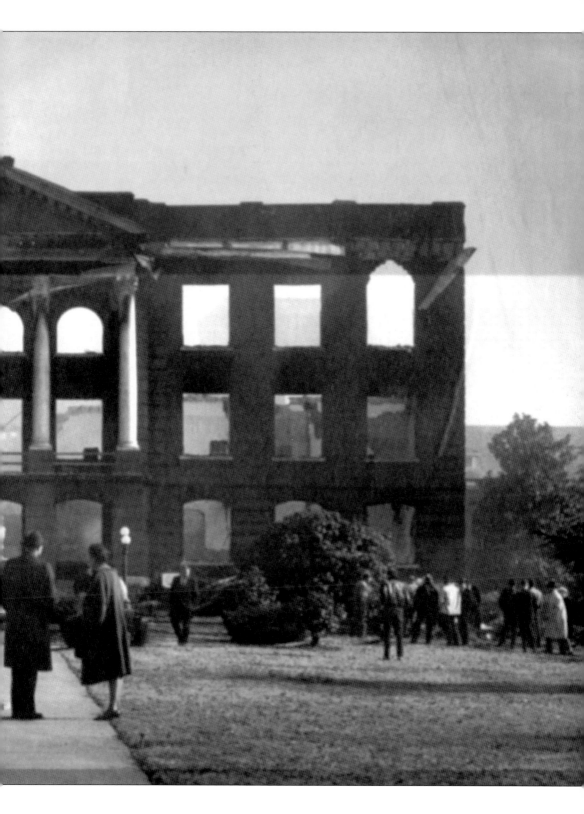

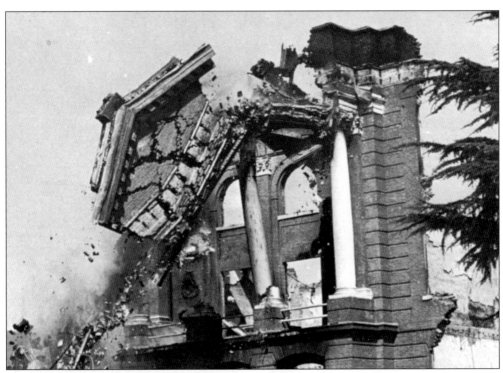

The shell of Old Main is demolished in February 1964.

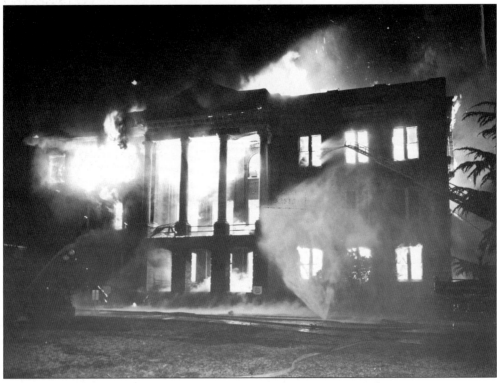

Old Main burns on the night of February 12, 1964, as firefighters work to control the flames.

Alawee Gibson Tucker, Class of 1939, is a former trustee and alumnae president. She has a reputation of being one of the college's best recruiters and faithful supporters. After the 1964 fire, Alawee and Alumnae Secretary Mary Ann Smith traveled many miles seeking help for the rebuilding program.

After the 1964 fire, alumnae felt they had lost a part of the campus that could be replaced only by columns. This gazebo represents the majestic columns of Old Main, East and West Wings. Alawee Tucker and other alumnae helped raise the money, while Zack Daniels, plant engineer, and his construction crew built it. Dedication of the Columns was held during Alumnae Weekend in May 1979, with Janet Cotter leading the ceremony. President Ralph Mirse; Ann Salter, alumnae president; and Alawee Tucker also participated. Some years later, columns returned in the Breed Leadership building.

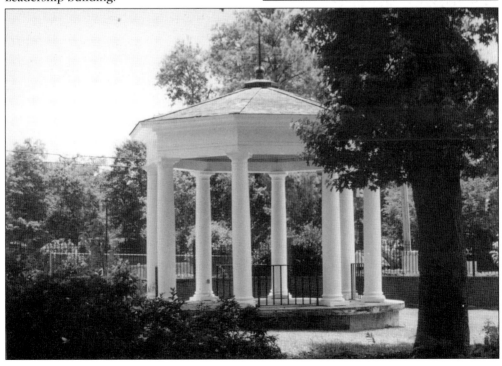

Janet Alexander Cotter stands in front of the lambrequins which were embroidered by alumnae Mrs. William S. Hall, Mrs. J.M. Ariail, Mrs. S.B. McClendon, and Mrs. Guy Malone. The lambrequins were given in 1971 to help complete the eighteenth-century parlor in Alumnae Hall. Janet Cotter was chairman of the centennial committee. Among other accomplishments, she began the college archives as a historical society while serving as president of the Alumnae Association.

Alumnae Hall, built in 1922, is the oldest building on the campus, and it served as the college's first library. It was a gift from the father and uncle of student Vera Young Thomas, who died shortly after the birth of her first child. "Vera Young Thomas Memorial Library" can still be seen etched above the building's main entrance.

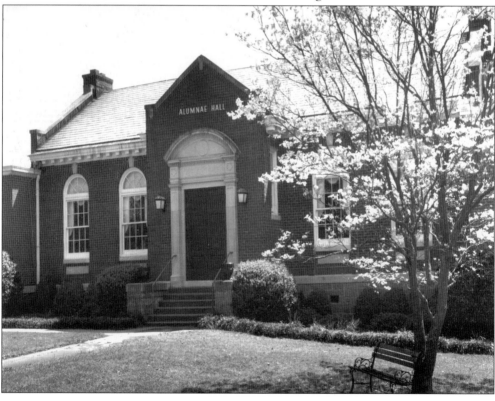

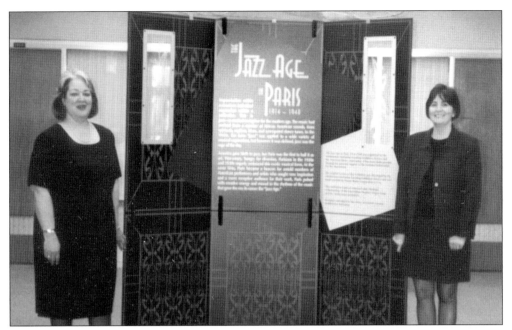

In 1999, Librarians Mary Cross, left, and Jane Tuttle, right, organized a six-week-long program of music, literature, and film celebrating the Jazz Age in Paris, 1914–1940.

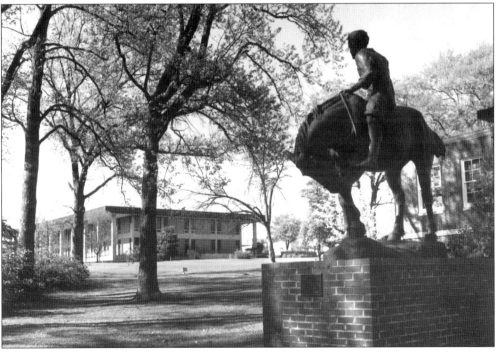

This view shows Edens Library with a statue of young Andrew Jackson by Anna Hyatt Huntington in the foreground, 1970s. President Wright Spears, who had admired Huntington statues in Brookgreen Gardens, approached the sculptor in the early 1950s with hopes of buying one of her works for the campus. Ms. Huntington graciously donated the Jackson statue to the college.

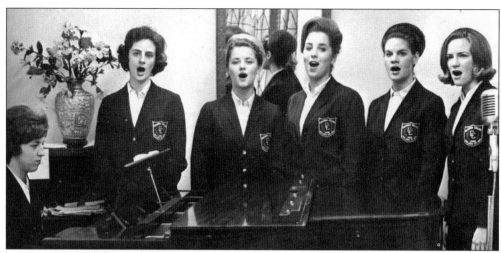

The High C's were a musical group who performed popular songs for civic groups and at college functions. Members from the 1966 group, from left to right, are Linda Sue Knight, Becky Dean, Joyce Cisson, Margy Oppenlaner, Marcia Hite, and Constance Player.

Physical Education instructor Lucille Godbold, known by students, colleagues, and friends as "Miss Ludy," takes the role of "Flaming Mame," the main attraction at the Faculty Foolies, 1967.

Sara Nalley, Class of 1963, receives a writing award from Dr. Ariail. Nalley is presently professor and chair of the department of speech and drama.

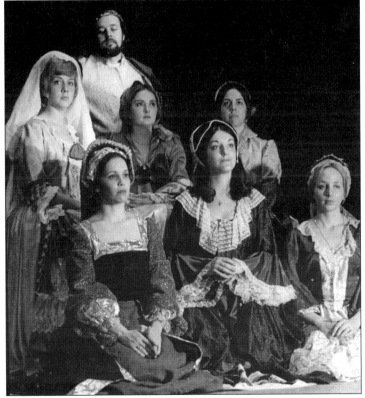

Students perform *Royal Gambit* in 1970. Henry VIII's wives are played, from left to right, by (front) Linda DuRant, Gail Brasington, and Jayne Portwood; and (back) Becki Bynum, Melanie Gause, and Sara Nalley. Tally Sessions at the top played the role of Henry VIII.

71

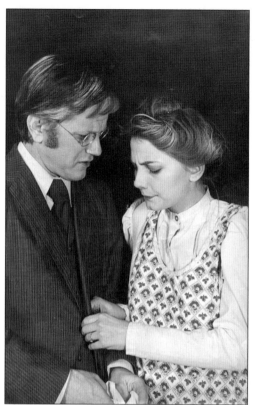

Class member of 1980, Genie Eaker, right, is shown with John Marion in a scene from the production of *Our Town*. Eaker is now director of Patchwork Playhouse. Her parents, Gene and Catherine Eaker, taught speech and drama at the college for more than 30 years each. Gene Eaker was longtime chair of the department of speech and drama.

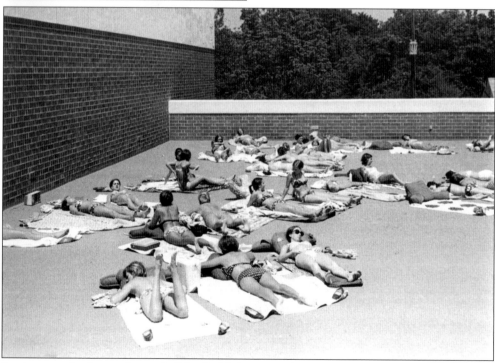

Students sunbathe on the roof of Godbold Center in the 1970s.

Student actor Annie McKnight played in *Grannie Annie* in 1986. She has pursued a career as a performer in comedy.

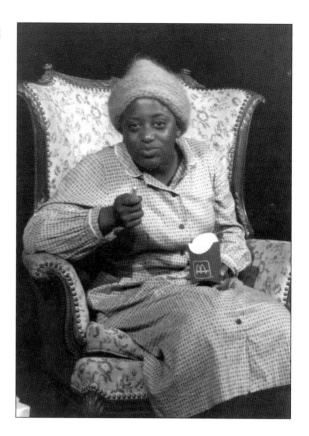

Shown here are the three little maids in the 1999 production of *The Mikado*, directed by Sidney Palmer.

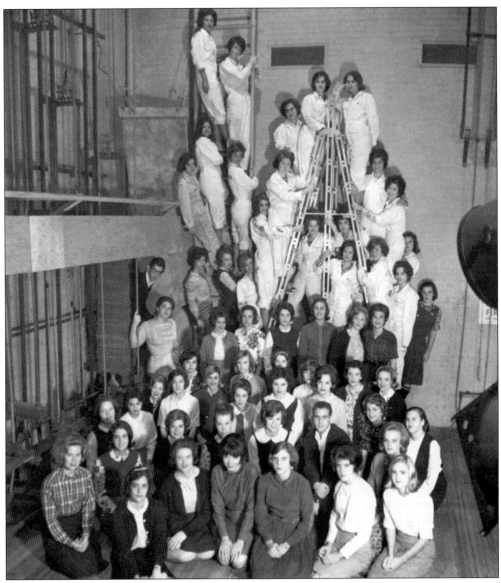

The Columbia College Players are shown backstage at Cottingham Theatre, 1965. During this year, the players presented *The Glass Menagerie*, *Brigadoon*, and *I Remember Mama*.

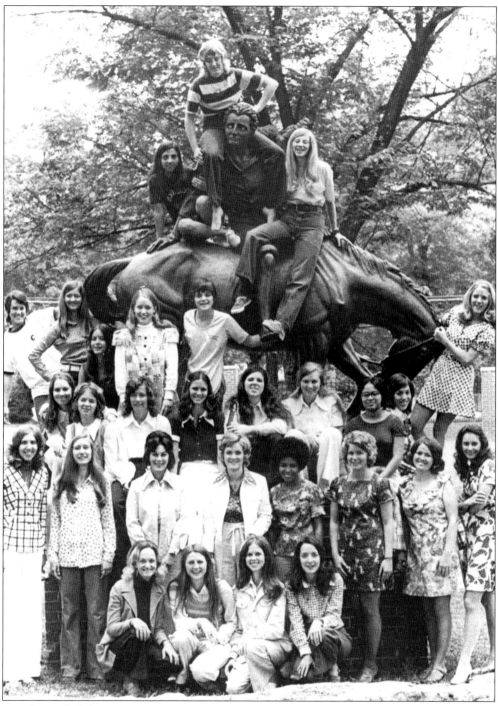

Members of Alpha Kappa Gamma, an honorary leadership fraternity, pose with Anna Hyatt Huntington's statue of young Andrew Jackson on campus in 1973.

The faculty of the department of dance and their children pose here in 1994. They are, from left to right, Libby Patenaude, Martha Brim, and Patricia Graham.

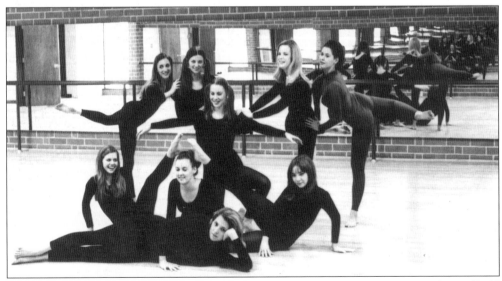

Student dancers perform at the Godbold Center Consecration, 1971. Miss Ludy Godbold was promised a gym when she came to teach at Columbia College in 1922. Limited funds and other needs pushed it back until 1971.

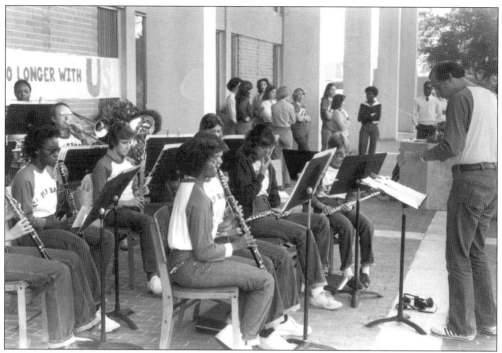

Music professor Randolph Love conducts the College Pep Band on the mall in the early 1990s.

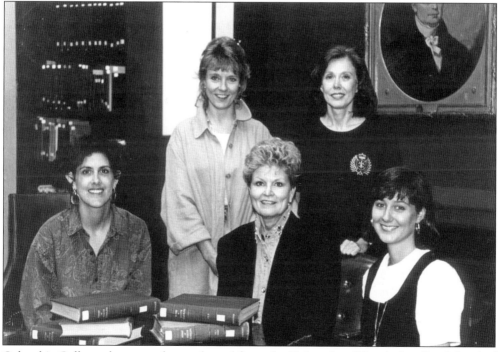

Columbia College alumnae who graduated from the University of South Carolina School of Law are pictured here in May 1994; from left to right, they are as follows: (seated) Cathy Dunn, Tootsie Kline, and Jennifer Rose; (standing) Kathy Randell and Linda Truluck.

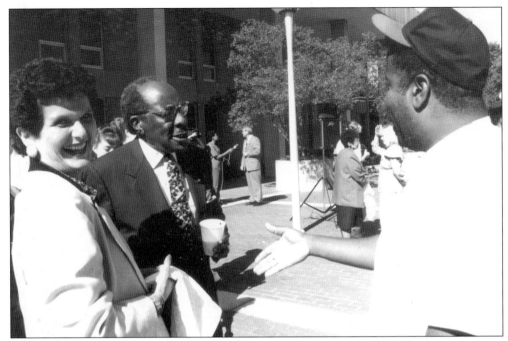

Director of the Columbia College Leadership Institute Mary J. Frame (left), South Carolina United Methodist Bishop Joseph Bethea (center), and Tony Pickett of the college's support services division (right) celebrate the announcement of the college's ranking by *U.S. News & World Report* as one of the top ten liberal arts colleges in the South, 1994.

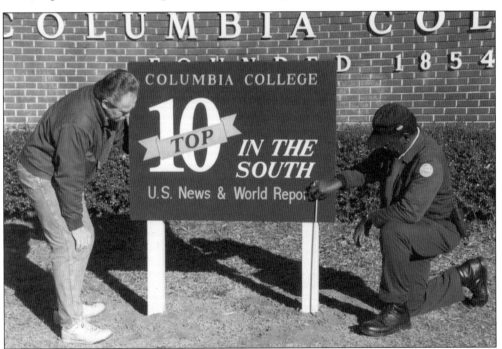

Columbia College has consistently maintained its top ten ranking by the *U.S. News & World Report*.

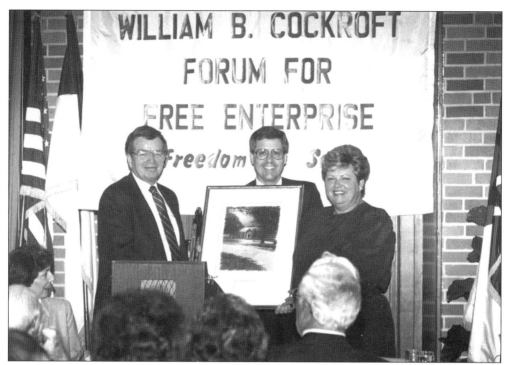

Johnnie Cordell Breed, at right, is seen here with her husband, Allen Breed, left, and President Peter Mitchell. In 1990, Johnnie Breed gave the college a lead gift of more than $1,000,000 for the construction of a new classroom building and leadership center. Breed was a member of the Board of Trustees.

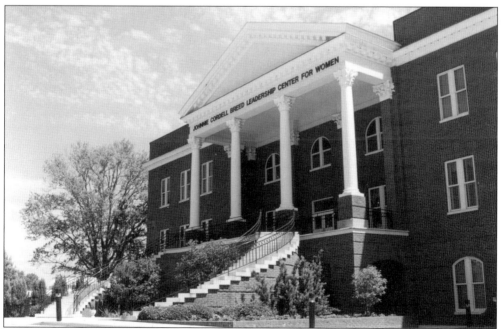

The Johnnie Cordell Breed Leadership Center for Women was completed in 1992. It stands near the location of Old Main.

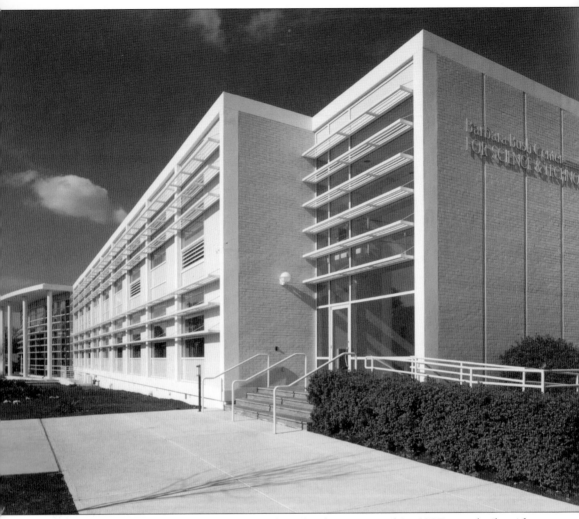

The Barbara Bush Center for Science and Technology, opened in 1997, was built with a major gift from Janice Suber McNair, Class of 1959, and her husband, Robert C. McNair. The McNairs requested that the building be named for their friend, former First Lady Barbara Bush.

Four

SOCIAL LIFE AND SPORTS

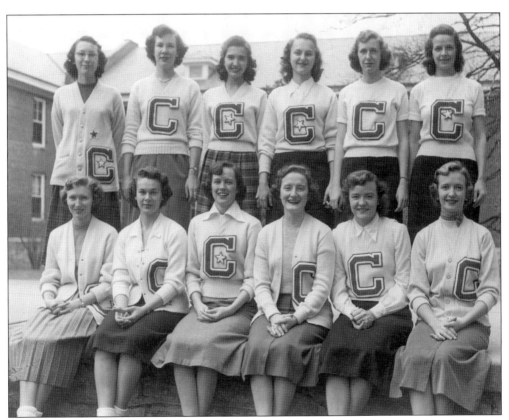

Block C members in 1953, from left to right, are (seated) Charlotte Brashier, Woodley Shingler, Mary Ada Huggins, Barbara Loadholt, Jerry Dennis, and Carol Ann Flowers; (standing) Jane Priester, Henrietta Rosson, Adelyn Grant, Mary Carolyn Tatum, and two unidentified students.

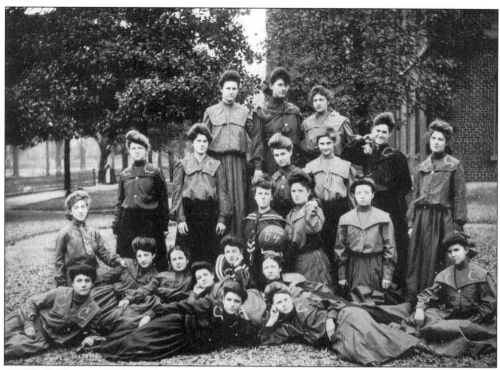

The College Athletic Association of 1904 is shown in this photograph.

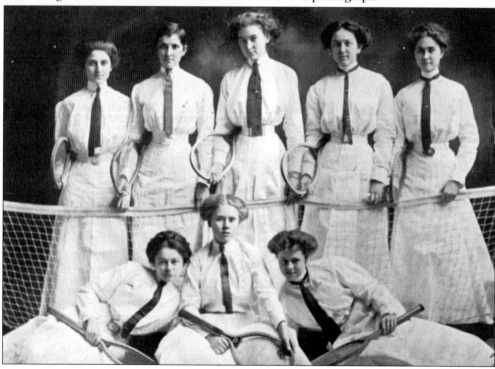

Members of the 1910 Racquet Club, from left to right, are Simsie McMichael, Ella Dukes, Orleana Cartledge, Edna Bates, Ellen Anderson, Willie Sherard, and Mary Townsend.

The varsity basketball team of 1916 included, from left to right, Captain Hettie Davis, Ola Baker, Von Etta Milhous, Edith Purvis, Annie Henagan, Winton Keaton, and Eulis Padgett.

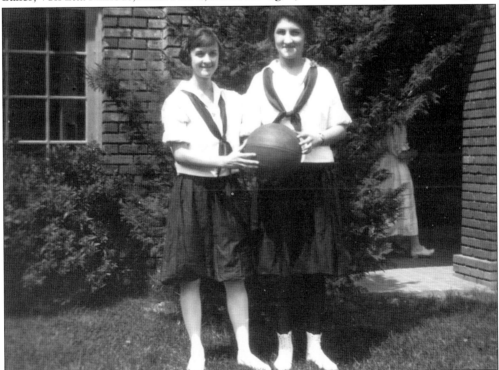

Basketball players Carol Hill Mundy and Elizabeth Killingsworth pose for this photograph in 1920.

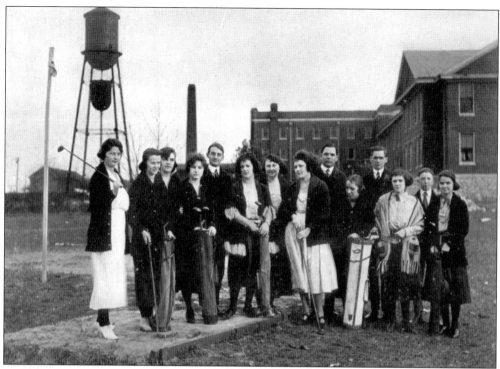

In 1925, President Guilds (back row, center) and Dr. Ariail (back row, left) joined these student golfers in practice.

This image shows the 1926 basketball team.

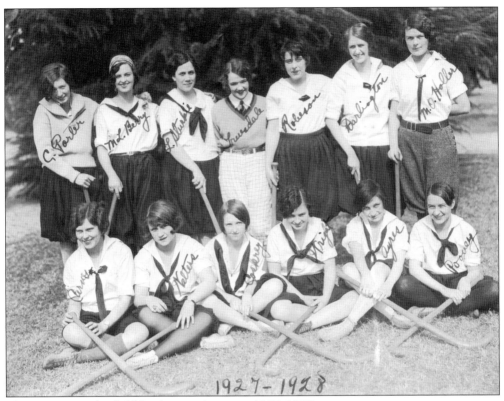

This group was the field hockey varsity team, 1927–1928.

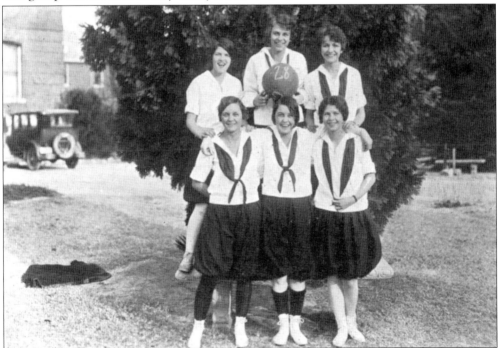

The junior basketball team is shown here in a 1928 photograph.

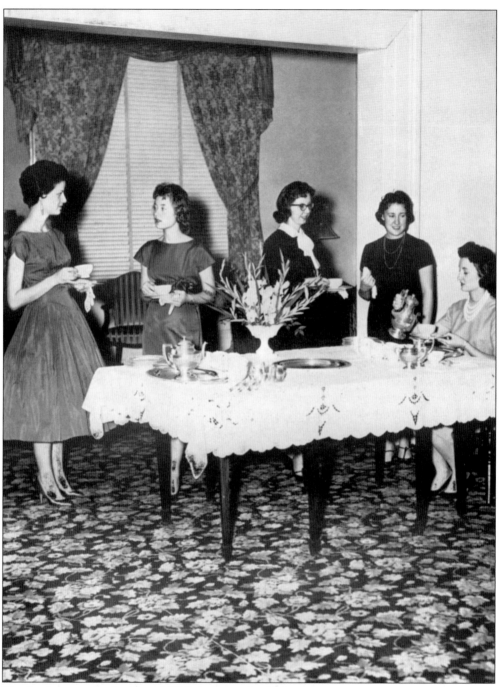

The Sophomore-Senior Tea of 1959 is shown in this image.

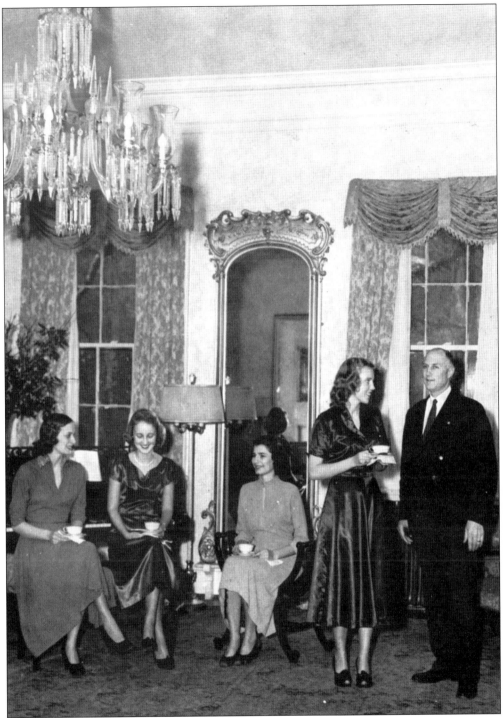

Students have tea with Governor Strom Thurmond and his wife, Jean, far left, in the Governor's Mansion in the 1940s. The students, from left to right, are Beverly Bryan, Agnes Heriot, and Mary Crum.

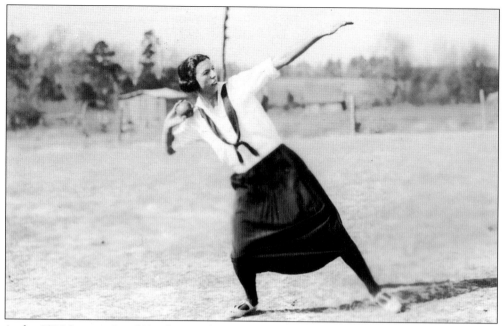

At the 1922 International Track Meet for Women, Miss Ludy Godbold broke the world shot put record. She came to the college in the fall of 1922 as the only member of the Physical Education department and taught physical conditioning for 57 years. In 1970, the new physical education building, Godbold Center, was named for her.

Left: Shown here is one of Miss Ludy's silver medals from the 1922 Track Meet for Women. *Right:* This is Miss Ludy's gold medal for shot put.

The junior tennis team is pictured here in the 1920s.

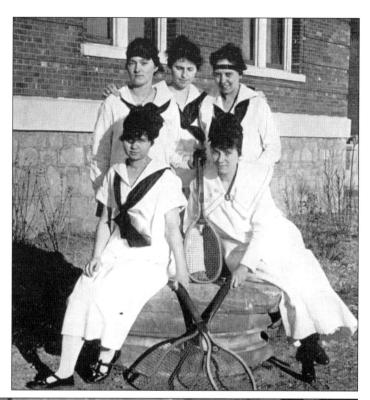

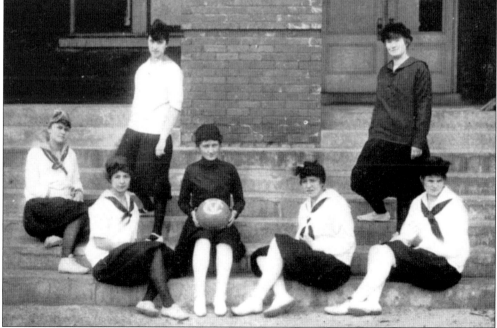

Members of the varsity basketball team of 1916, from left to right, are Captain Hettie Davis, Ola Baker, Von Etta Milhous, Edith Purvis, Annie Henagan, Winton Keaton, and Eulis Padgett. Later, Von Etta became Mrs. Sally, a well-remembered librarian from 1929 until her retirement in 1967.

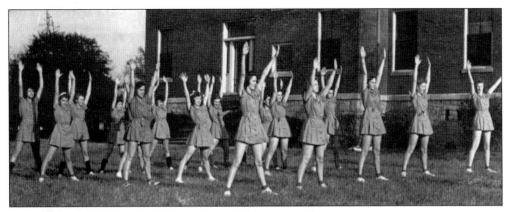

Students perform exercises to keep fit in 1943.

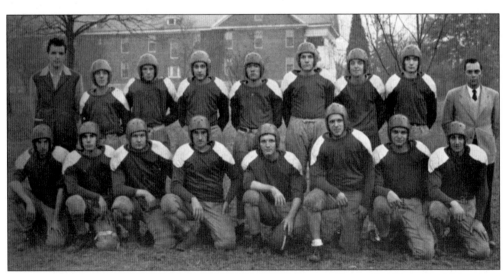

The Columbia College men's football team is pictured here in 1947. Men on the G.I. Bill were admitted to the college after World War II. Currently, men are admitted as non-resident students to the Evening College and to the graduate and summer school programs.

90

Miss Ludy crowns the Queen of the Ludy Bowl in the 1970s. Ludy Bowl, which began in 1951, is a flag football game, pitting the sophomore and juniors against the freshmen and seniors. It has come to serve as the college's "homecoming" event.

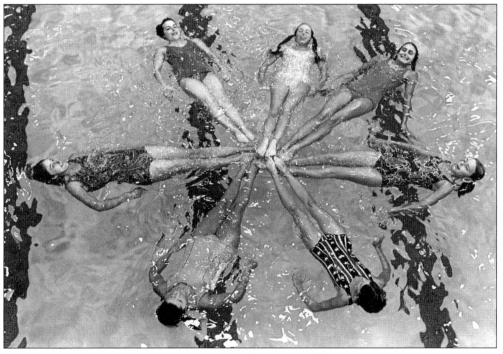

A water ballet is performed by the Poseidon Club, early 1970s.

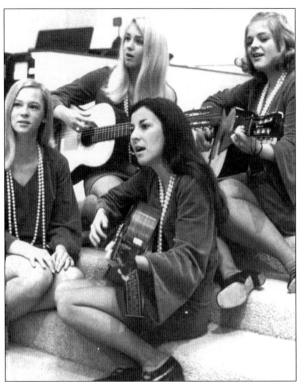

This musical group in the 1970s was called The Ladybugs. Members, from left to right, were Mary Lee Smith, Kay Keels, Susan Wheeler, and Barbara Gay.

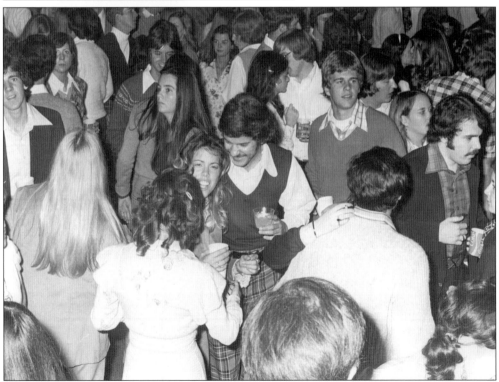

A college dance is pictured here in 1970.

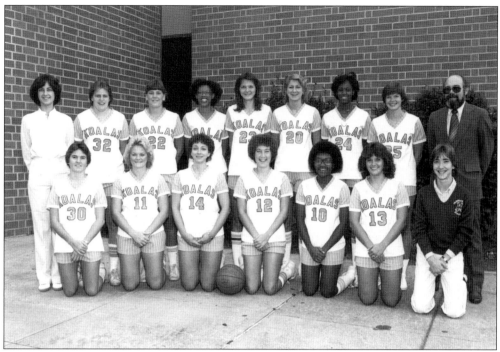

The 1982 Fighting Koalas basketball team, seen here, was coached by education professor Don Patenaude, standing at right.

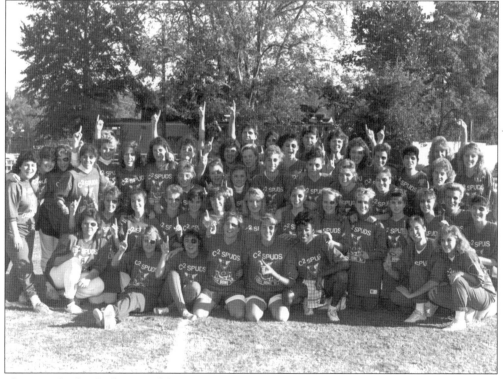

The "Spuds" football team of the 1987 Ludy Bowl is shown in this image.

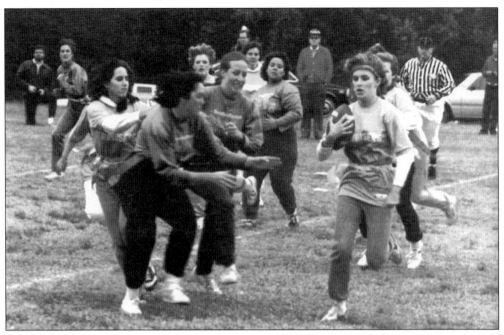

The defense attacks in the 1983 Ludy Bowl.

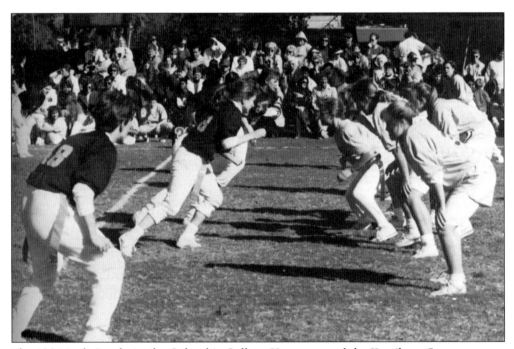

The 1991 Ludy Bowl pits the Columbia College Hammers and the Kamikaze Crew.

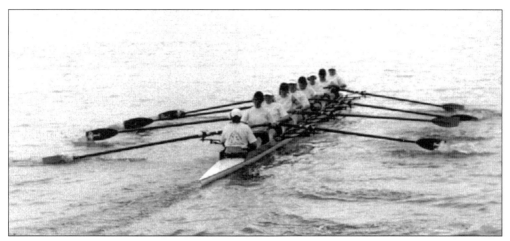

The Columbia College crew, established in fall 1999, practices on Lake Wateree.

Students compete during "Fun Day" in 1999.

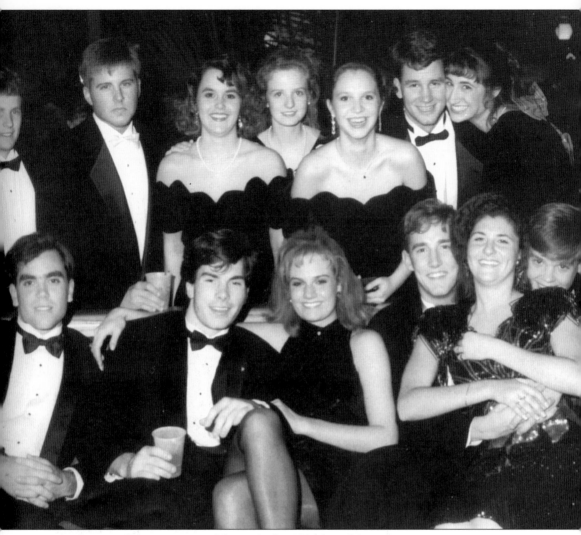

Students and their escorts celebrate at the 1994 May Dance.

Five
COLLEGE LEADERS, ALUMNAE, AND VISITORS

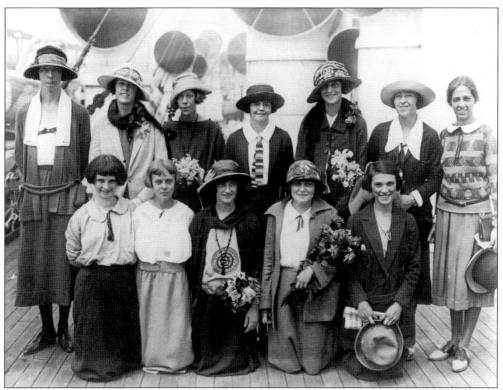

Lucile Ellerbe Godbold, standing at the far left, is pictured with other athletes of the American team headed for Paris and the first International Track Meet for Women in the summer of 1922. Miss Ludy returned with six championship medals, which she modestly kept at home in a drawer for years. The medals were given to the college by her nephew, Dunbar Godbold, in 1981.

Dr. Griffith T. Pugh became president in 1916. Prior to his presidency, he taught mathematics and astronomy at the college for ten years. He was president for four years.

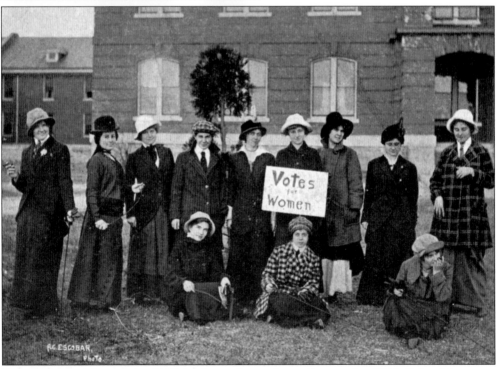

The Suffragists' League in 1915 is shown here. According to the 1915 *Columbian*, one member, not pictured here, was "expelled for militantism."

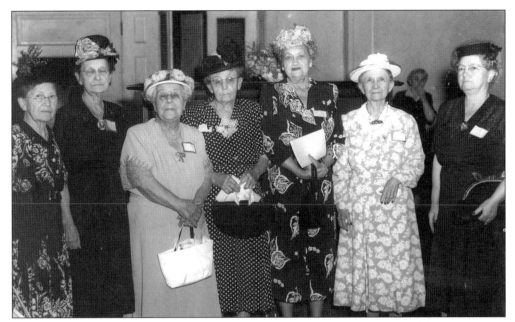

Alumnae visit on Alumnae Day, May 29, 1949. They are, from left to right, as follows: Edith M. Pooser (1894), Lulie Cauthen (1889), Meta McJunkin Hewell (1885), Carrie Rast Summersett (1889), Eloise Welch Wright (1892), Sallie Jones Wooten (1884), and Emmie Rawl Cartledge (1900).

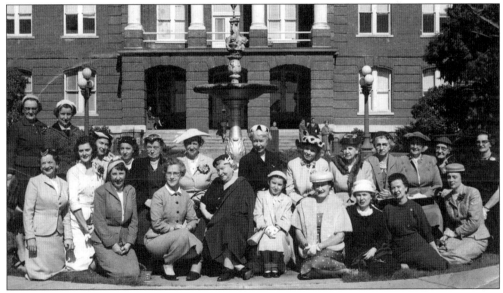

This image of the Alumnae Association appeared in the 1957 *Columbian*. Those pictured, from left to right, are (front row) Miss Janet Alexander, Mrs. S.C. Groeschel, Mrs. Alex Cunningham, Mrs. Jack Lightsey, Miss Will Lou Gray, Mrs. Eva Covington, Mrs. Sam McGregor, Mrs. Leslie Patterson, Mrs. J.W. Dantzler, and Mrs. G.E. Cushman; (back row) Mrs. J.F. Cantwell, Mrs. F.B. Collins, Mrs. L.D. Chisholm, Mrs. H.G. Hendrix, Mrs. S.B. Cartledge, Mrs. J.M. Ariail, Mrs. J.A. Henry, Mrs. R.H. Miller, Miss Ruth Emmala Miller, Mrs. T.W. Munnerlyn, Miss Ella May Atkinson, Mrs. P.S. Connor, and Mrs. B.E. Allen.

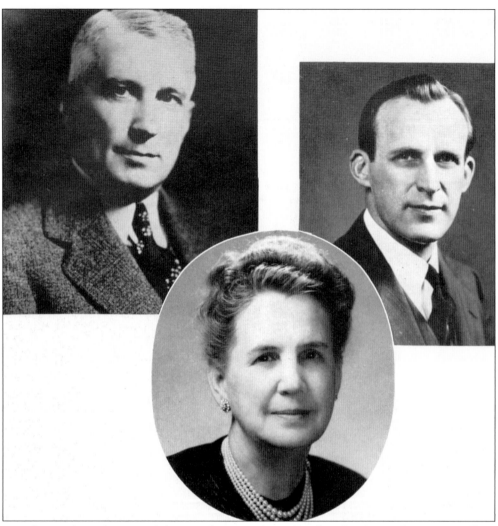

President Walter K. Greene, left, served as president of both Columbia College and Wofford College from 1948 to 1950. The two colleges were united under a common board of trustees in November 1948 in an effort to achieve economy and efficiency. The Methodist Conference went into lengthy debate about the virtues and liabilities of the consolidated system, deciding in 1951 "to reinstate both colleges with their own autonomous boards and their respective presidents," according to Helen Jordan, college librarian. Dr. Oscar W. Lever, right, served as dean of administration at Columbia College during the consolidation period. Before coming to Columbia, Lever had served at Wofford as assistant to the president, director of public relations and alumni affairs, and chairman of the department of philosophy. Pictured in the center is Louise Fridy Munnerlyn, Class of 1908, who was dean of women, 1936–1955. She is remembered for her graciousness and her efforts to instill good manners in students. One alumna remembers her saying, "A lady never chews gum in public!"

Dr. J.M. Ariail reads at home in the 1940s.

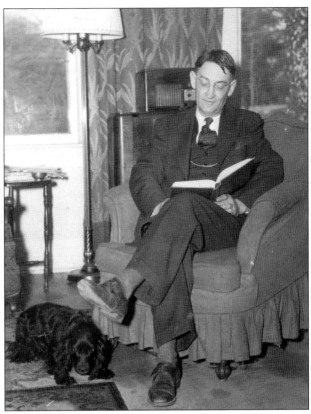

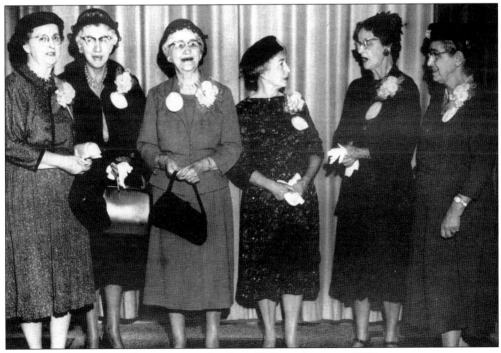

Members of the Class of 1911 return for their 50th anniversary, 1961.

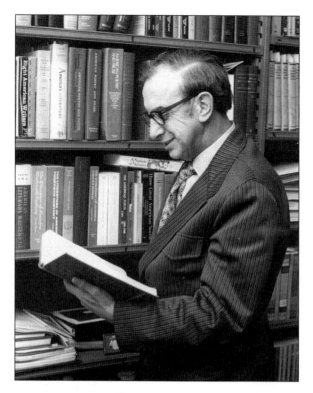

Dr. Henry Rollins succeeded Dr. Ariail as chair of the English department in 1956. During his tenure, he traveled with students to England to participate in a course in Shakespeare taught at Stratford-upon-Avon. Rollins died in 1972.

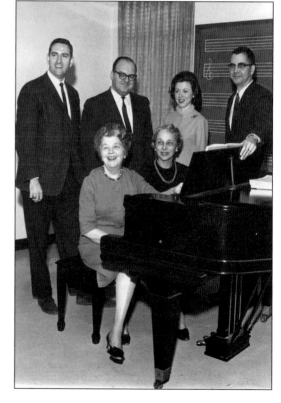

The Music department faculty in 1967, from left to right, are (seated) Margarette Richards and Frances Jones; (standing) Walker Breland (department chair), Gordon Myers, Lanny Palmer, and Guthrie Darr. Lanny Palmer, Class of 1953, is now a professor of music and has taught at Columbia College since 1963. Her daughters Ann and Mary are also alumnae. Margarette Richards taught piano at the college for 37 years. A concert artist, she performed until the year before her death in 2001.

Tata Baer and JoAnn
Rainey meet
Richard M. Nixon on
the Presidential
campaign trail in 1960.

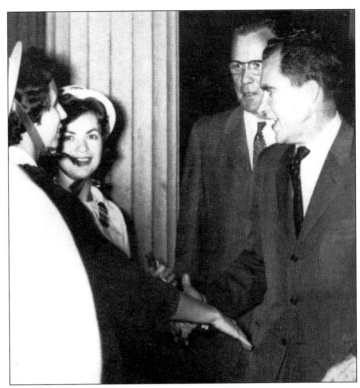

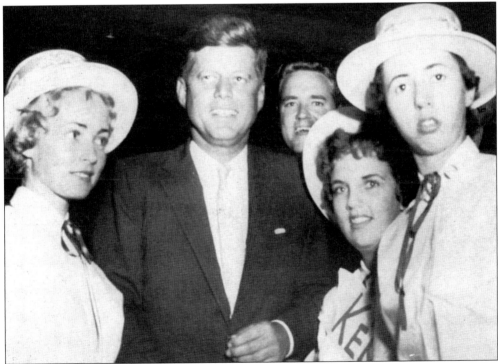

Claire Altman, Ouida Scott, and Tata Baer appear with John F. Kennedy and Governor Fritz
Hollings (background) in 1960 during the Presidential election campaign.

Clelia Derrick Hendrix, Class of 1941, became the first alumna chairman of the board of trustees in 1970.

Bob Barham came to the college in 1958 at the request of President Wright Spears. Barham worked for more than 35 years in public relations, as a business officer, and in development.

Elizabeth Johnston Patterson, Class of 1961, was the first woman elected to the U.S. Congress from South Carolina. She is pictured here in 1967. She later became a member of the board of trustees.

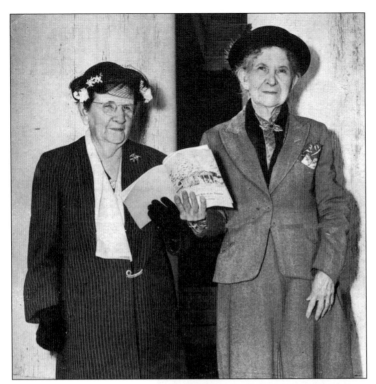

Mrs. Olive Burrows Newman, Class of 1895, (at left) and Mrs. Sally Jones Wooten, Class of 1884, were both living in Columbia in 1953 when this photo was made for *The State Magazine*. Olive's mother, Harriet Glaze, was one of the first graduates in 1860. Mrs. Burrows said her mother and others from the Lowcountry entered Columbia Female College thinking of it as a place of refuge from the rising tide of the Civil War.

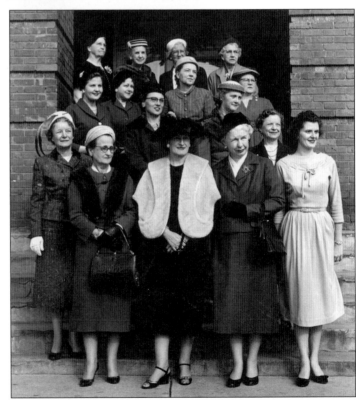

The Alumnae Council of 1957–1958 is shown in this photograph.

Ruth Henry Lightsey, Class of 1928, was
the college registrar for many years and
helped establish the college archives. She
managed to save records and
photographs and served on the Alumnae
Council for a number of years.

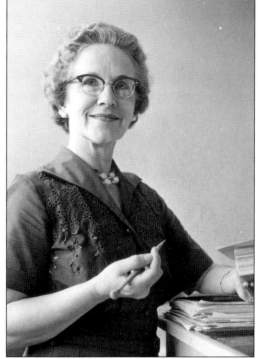

Officers of the Alumnae Association in
1961 were from left to right as follows:
(top row) president, Mrs. Leon Johnson;
first vice president, Mrs. T.H. Roper;
and second vice president, Mrs. Harry
Harvin Jr.; (bottom row) secretary, Mrs.
C.M. Tucker Jr.; and treasurer,
Mrs. Donald Stratton.

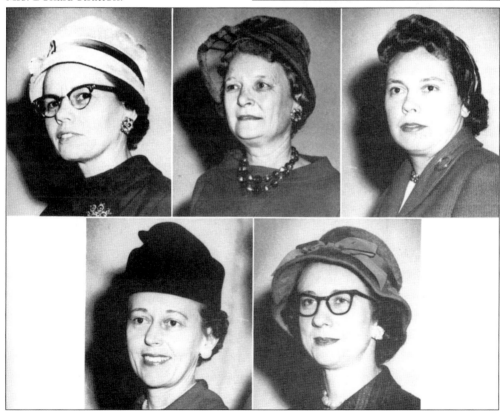

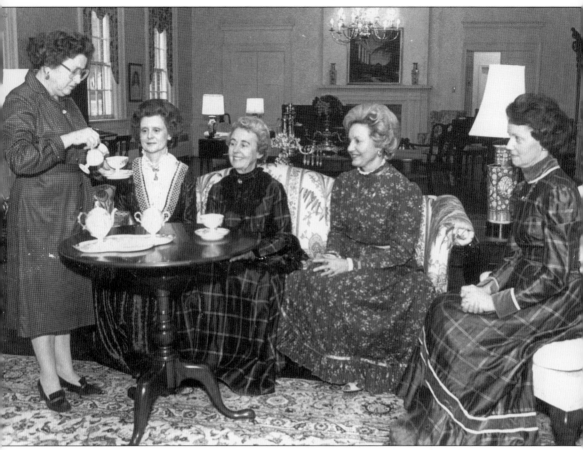

The alumnae centennial, 1964, was celebrated in period dress by the following people, from left to right: (seated) Janet Alexander Cotter (1956), Anne Harrell (1957), Edith Hause (1956), and Alawee Tucker (1939). Pouring tea is Julia Hyatt Huffman, great-granddaughter of benefactor F.H. Hyatt.

Students dedicated the 1966 *Columbian* to the Reverend Eben Taylor. He was pastor of College Place United Methodist Church during the 1964 fire and at the time when the church and college became integrated. His was a stabilizing force as he became a counselor and an inspiration to students and church members.

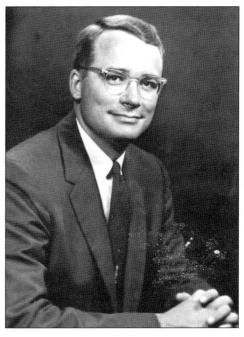

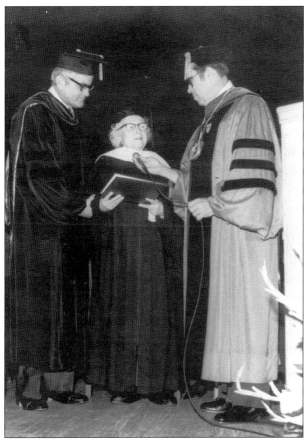

Dr. Wil Lou Gray, Class of 1903, (center) was known as South Carolina's "First Lady of Adult Education." She was the founder of the Wil Lou Gray Opportunity School and spent most of her 100 years fighting illiteracy in the state. At left is Dean of the College William W. Butler, who later became the college chaplain. Wil Lou Gray is receiving an honorary doctorate from the college, presented to her by President Ralph Mirse. She was the first recipient of the Alumnae Distinguished Service Award in 1978. In 1926, two alumnae, Wil Lou Gray and Ivah Epps Frierson, were elected to the previously all-male board of trustees.

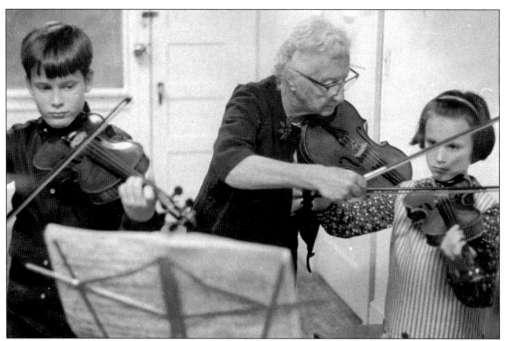

Beatrice ("Miss Bea") Horsbrugh taught violin and French from 1960 until her death in 1981. She was also assistant concertmaster of the Columbia Philharmonic Orchestra, which she helped found. Miss Bea was a childhood friend of, and fellow student with, Jasha Heifetz when both studied with Leopold Auer in Russia.

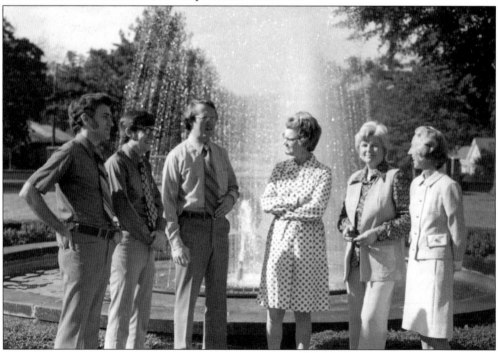

The English department faculty in the mid-1970s, from left to right, were Billy Mishoe, Michael Broome, Jerold Savory, Sara Mott, Rhea Workman, and Mary Hatch.

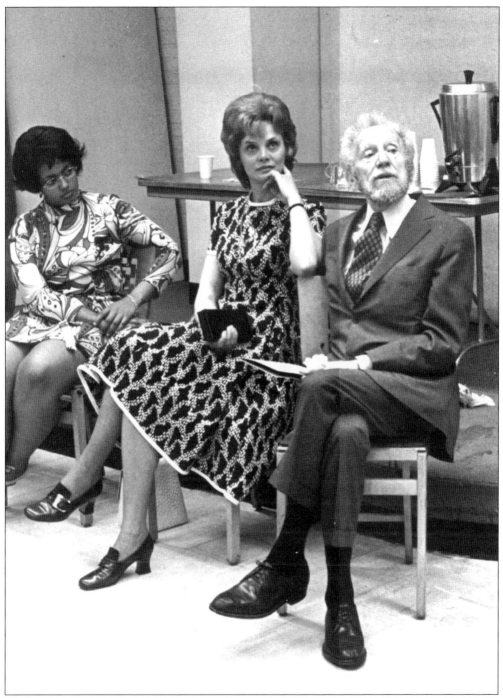

Bettye Ackerman Jaffe, Class of 1945, (center) and her husband, Sam Jaffe, are shown on a visit to the college in 1980. The two starred on the popular television drama series *Ben Casey, M.D.* in the 1960s. Bettye now lives in Columbia and recently held an exhibition of her paintings.

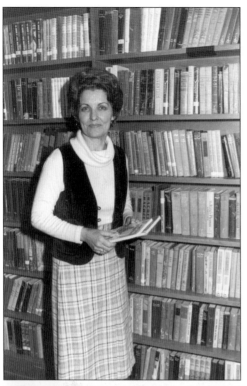

Idella Bodie, Class of 1946, is the author of fiction, history, and children's books. In 1998, she published a memoir of her literary life, *Carolina Girl: A Writer's Beginning*.

Shown is Susie Thomas at the unveiling of her portrait at her retirement. Mrs. Thomas was a friend to generations of students. Introducing her is Mrs. John Eastman, president of the Alumnae Association. Anne Beebe, Class of 1950, and president of the Alumnae Association from 1985 to 1987, is standing at the far right.

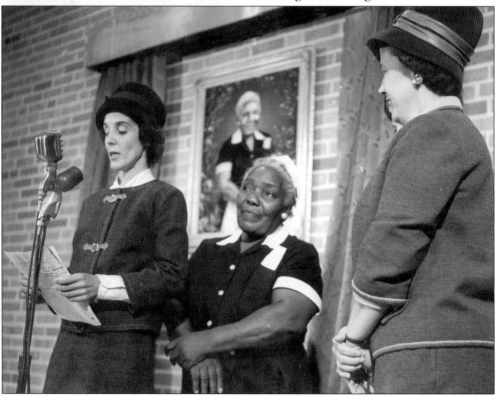

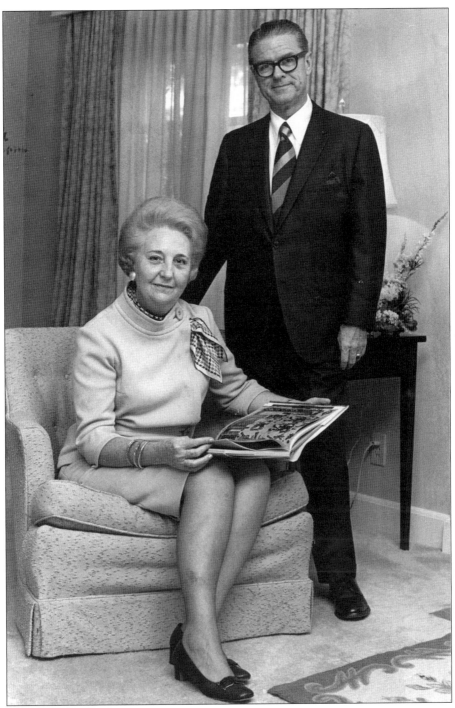

The college's 12th president, Dr. R. Wright Spears, and his wife, Mary Blue Spears, are pictured in the president's home. Spears was president from 1951 to 1977. His initial goals, all of which were realized during his tenure, were to bring the college and church closer together, to develop a strong and sound academic reputation for the college, and to build an adequate physical plant.

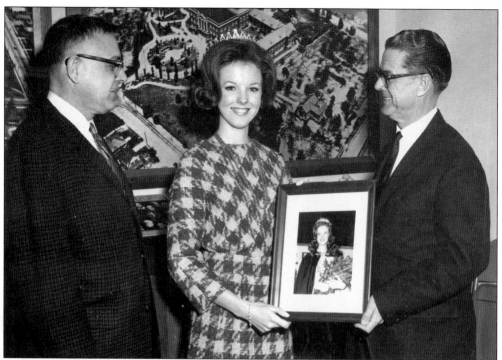

Ruth Ann Collins, Class of 1968, (center) poses with President Wright Spears (at right). Collins was the 1968 Miss South Carolina. Dean Thomas D. Shuler is standing at left.

Dr. Jerold Savory presents a copy of his book *Columbia College: The Ariail Years* to South Carolina's First Lady, Mrs. Richard Riley, in 1979. Belva Ariail, widow of Dr. J.M. Ariail, left, and Lula Hill, right, look on.

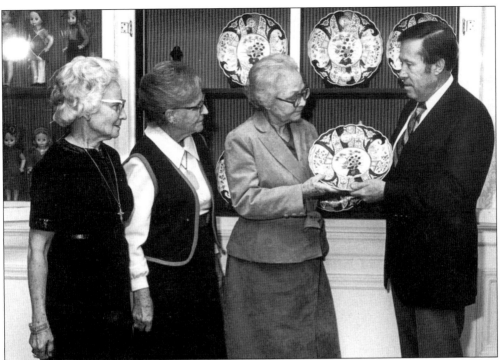

Charlotte (Class of 1924), Lalla (Class of 1923), and Foy Stevenson were friends and benefactors of the college. Charlotte is shown presenting pieces of Imari china for Alumnae Hall to President Ralph Mirse in 1980.

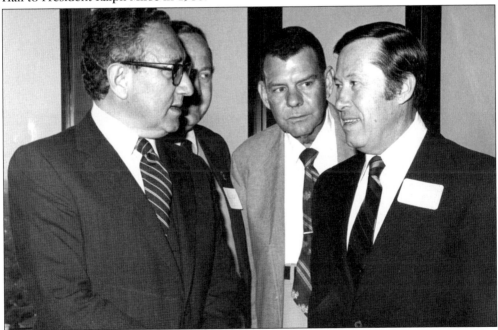

President Ralph Mirse, far right, talks with Ambassador Henry Kissinger and political activists Harry Dent and Drake Edens on the occasion of Strom Thurmond's birthday in 1971.

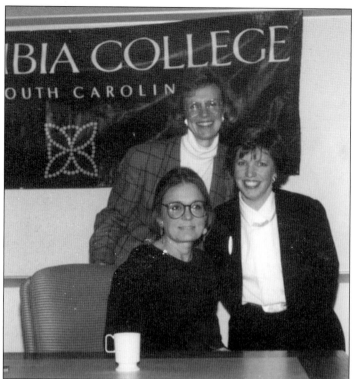

Author Gloria Steinem, seated, visits the campus in 1993. Also pictured are Meg McLean, left, and Beth Burn, right, of the college's public relations office.

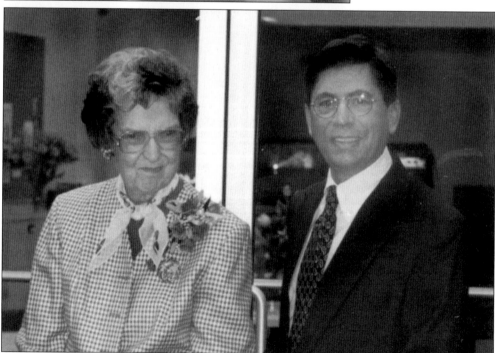

Nell Williams Overton, Class of 1943 and college benefactor, cuts the ribbon for the dedication of the Overton Media Center in Edens Library on March 4, 1999. Director of Edens Library John Pritchett assists.

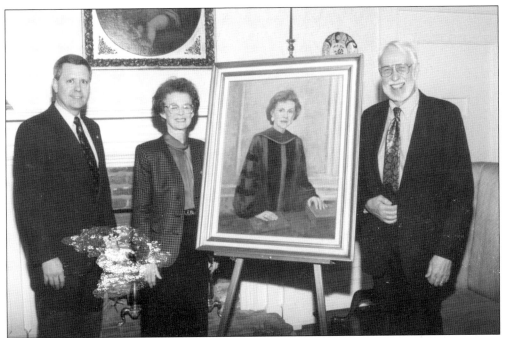

Dr. Miriam Rawl, professor and academic dean, is pictured at the unveiling of her portrait at her retirement. President Peter Mitchell stands at left, and Professor Charles Pfeiffer, at right.

Marjorie Patterson, Class of 1949, heads the decorating committee for the annual Christmas Coffee that alumnae give for faculty and staff, for the 50th reunion luncheons, and for other special occasions. A College Medallion recipient, she was also State Mother of the Year in 1995.

Annie Laurie Kennerly George, Class of 1933, is a retired teacher who operates a ministry for the poor with her two sisters, Mildred Hendrix, Class of 1944, and Gussie Johnson, Class of 1935. She is a recipient of the College Medallion and gave the furnishings for the college archives.

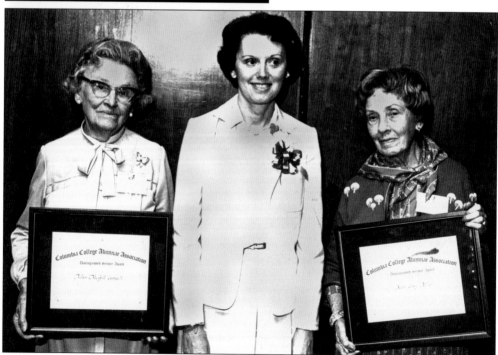

Niven McGill Cantwell, left, and Ruth Crary Miller, right, both Class of 1919, receive the Distinguished Service Award from Ann Harrell, president of the Alumnae Association. Niven and Ruth were loyal alumnae and staunch supporters of the college throughout their lives.

T.J. Harrelson, former chairman of the
board of trustees and a staunch friend and
benefactor of the college, was a leader in
the massive rebuilding after the 1964 fire.
He is seen here at the 1967 homecoming.
The Harrelson Student Center is named for
him and his wife, Faye.

Dr. Belinda Gergel, Class of 1972, is a
professor and former chair of the
department of history and political science.
Professor Gergel was one of the original
planners for the Evening College program,
has been active in state and national
politics, and is co-author with her
husband, Richard Gergel, of a history of
the Jewish communities in South Carolina.

President Peter T. Mitchell, the college's 14th president, and his wife, Becky Mitchell, are pictured here. Mitchell was president from 1988 to 1997. His goals were to create at the college a "collaborative learning environment in which students become . . . actively involved in education" and to make leadership "an integral and pervasive part of the curriculum and extra-curricular life."

Karen Johnson Williams, Class of 1972, was the first woman appointed to a judgeship in the U.S. Fourth Circuit.

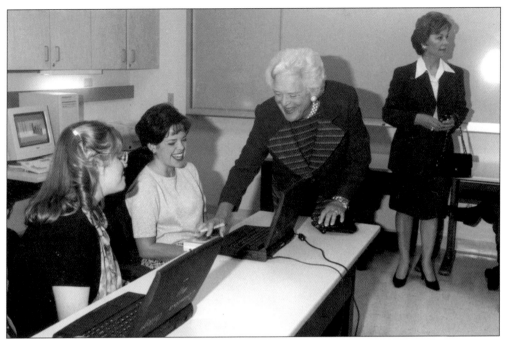

During her tour of the new science building, Barbara Bush laughs with students. Janice McNair is seen in the background.

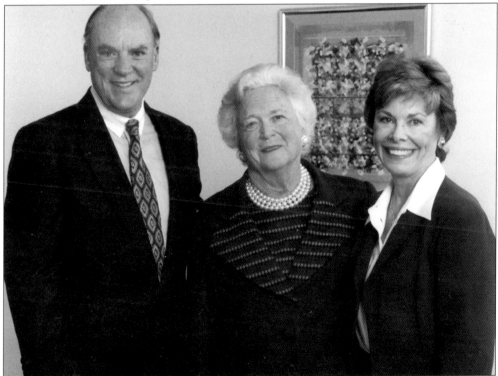

Former First Lady Barbara Bush is pictured here with Janice and Robert McNair on the occasion of the dedication of the Barbara Bush Center for Science and Technology, 1997.

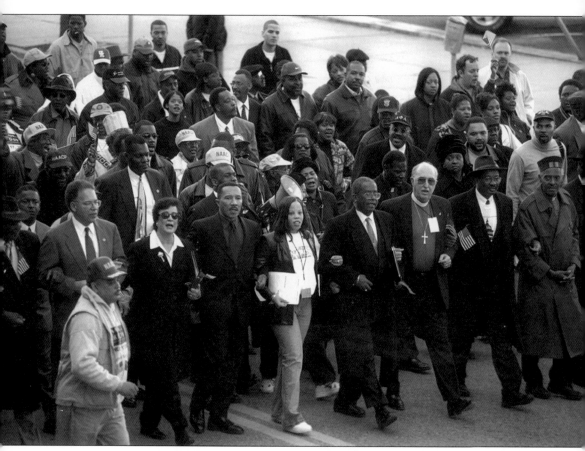

In 2000, hundreds of Columbia College students, faculty, and staff rallied to petition the South Carolina Legislature to remove the Confederate flag from the dome of the Statehouse. President Phyllis Bonanno (third from left) leads a protest march to the Statehouse. National NAACP President Kweisi Mfume is seen on Bonanno's left. United Methodist Bishop Lawrence McClesky, in clerical collar, is visible on the front row, fourth from right.

History Professor Robert Moore talks with a student on the Mall in 1995. With a student faculty ratio of 12 to 1, the college has always prided itself on personal attention to students.

History professor Selden Smith is shown in his office, 1966. Professors Smith and Moore have served as champions of faculty governance and protectors of academic freedom for a combined tenure of over 75 years.

Phyllis O. Bonanno, at left, became the college's first woman president in 1997. She is pictured here at her 1998 inauguration with personal friend and inauguration speaker Lynda Johnson Robb, daughter of President Lyndon Johnson.

Rebecca Laffitte, Class of 1977, is an attorney with the firm of Sowell, Todd, Laffitte, Beard, and Watson in Columbia. Among other honors, Laffitte has received the Career Achievement Award from the Alumnae Association.

Ginger Crocker Lloyd, Class of
1973 and a former member of the
South Carolina House of
Representatives, is director of
intergovernmental and
community relations in the
Governor's Office of Executive
Policy and Programs.

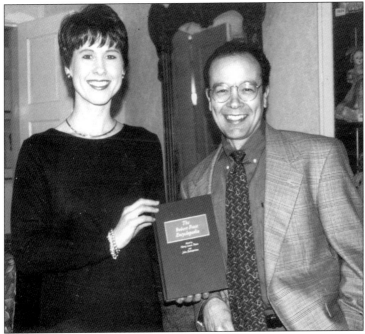

English Professors
Nancy Tuten and
John Zubizarreta
celebrate the
publication of their
book, *The Robert
Frost Encyclopedia*,
in 2000.

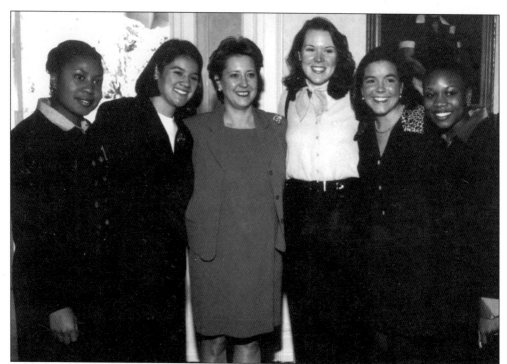

First Lady of South Carolina Rachel Gardner Hodges (third from left), Class of 1982, founded the "Reading with Rachel" program, which she has taken to schools statewide. She can be heard weekly reading children's books on the South Carolina Educational Radio Network. She is pictured here with students, from left to right, Keisha Green, Cristina Diano, Erin Rinquist, Sara Boggs, and Melody Blake.

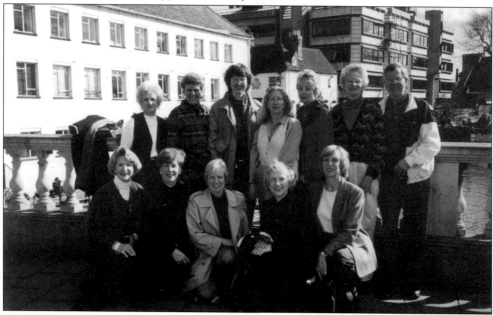

A group of faculty, staff, and alumnae participated in a travel-study tour of London in May 1999, sponsored by the department of history and political science.

Dr. James H. Rex, at right, was the college's 16th president. President Rex served from 2000 to 2001. He is seen here with Superintendent of Richland County School District One Ronald L. Epps.

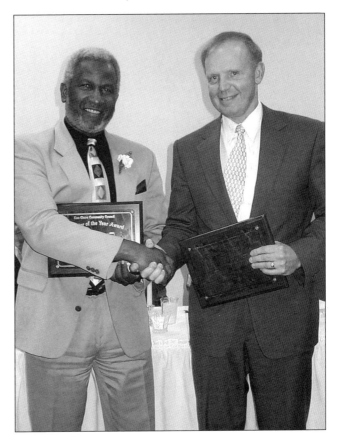

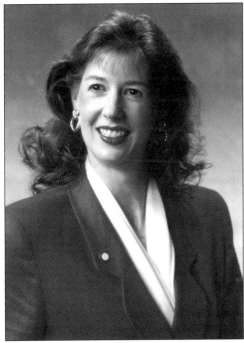

Emil Burns Mitchell, Class of 1984, was Alumnae Association president from 1999 to 2001. She wove the theme "Gifts of Life" into her tenure, led efforts to initiate changes in the Association bylaws, and updated the committee structure in order to attract younger members. Master of Social Work Supervisor at Palmetto Health Hospice in Columbia, she serves as an adjunct professor in the Evening College social work program and is also a member of the Columbia College Coalition for Social Work Education.

Dr. Caroline Whitson, 17th president of the college, took office in July 2001.

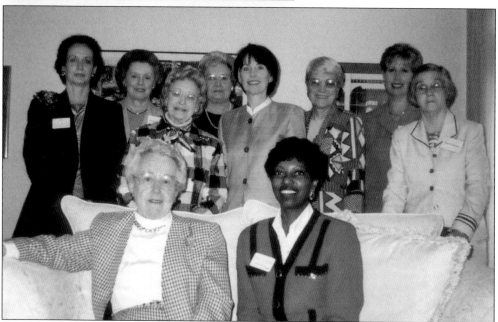

President Whitson visited the campus in May 2001 and met with presidents of the Alumnae Association. Seated are Alawee Tucker and Margie Mitchell, president-elect. Standing, from left to right, are Marlena Myers, office of alumnae relations; Anne Harrell; Clelia Hendrix; Edith Hause, office of alumnae relations; Whitson; Patsy Whitaker; Bootsie Harvie Wynne, current alumnae president; and Sara Eastman.